Masterpieces
of the J. Paul Getty Museum

PHOTOGRAPHS

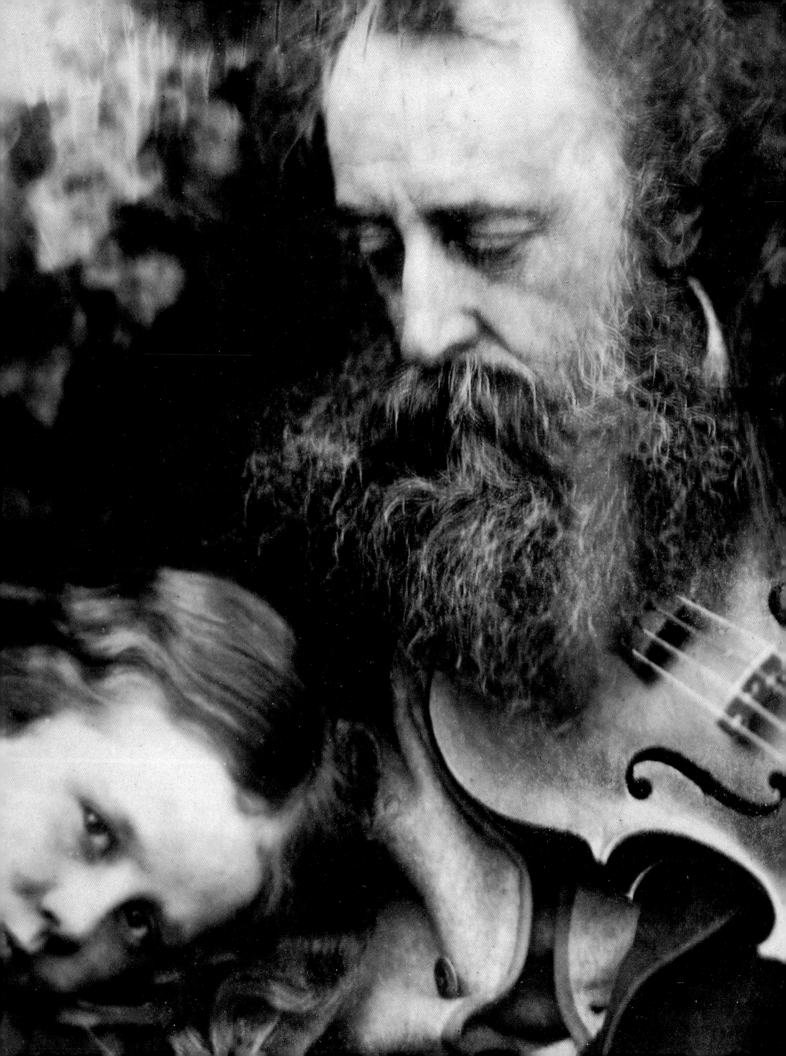

Masterpieces of the J. Paul Getty Museum

PHOTOGRAPHS

THAMES AND HUDSON

Frontispiece:
JULIA MARGARET CAMERON
English (born India), 1815–1879
The Whisper of the Muse/Portrait of
G. F. Watts [detail], April 1865
Albumen print
84.XZ.186.96 (See no. 7)

Text prepared by Gordon Baldwin,
Julian Cox, Michael Hargraves, Judith
Keller, Anne Lyden, John McIntyre,
Weston Naef and Katherine Ware

The following photographs are
reproduced courtesy of their
copyright holders:
no. 31 © Aperture Foundation
no. 32 © 1981 Arizona Board of
Regents, Center for Photography
no. 34 © Man Ray Trust ARS-ADAGP
no. 43 © Estate of André Kertész
no. 44 © Willard and Barbara Morgan
Archives
no. 47 © Estate of Lisette Model
no. 49 © Frederick Sommer
no. 50 © Estate of Edmund Teske.

The J. Paul Getty Museum
acknowledges the cooperation
of The Walker Evans Archive at
The Metropolitan Museum of Art.

© 1999 The J. Paul Getty Museum
1200 Getty Center Drive
Suite 1000
Los Angeles, California 90049-1687

Designed and produced by Thames and Hudson and
copublished with the J. Paul Getty Museum

British Library Cataloguing-in-Publication Data

A catalogue record for this book is available from the British Library

ISBN 0-500-16029-5

Colour reproductions by Articolor, Verona, Italy

Printed and bound in Singapore by C.S. Graphics

CONTENTS

FOREWORD

As we prepare for the close of the twentieth century and the opening of the twenty-first, the time is right to publish this sampling of the J. Paul Getty Museum's photographs and thereby celebrate the only art form in our collection that represents contemporary life.

Photography entered the Getty Museum in 1984, when the Trustees agreed to acquire the entire holdings of a number of important private collectors. These included Samuel Wagstaff, Volker Kahmen and Georg Heusch, and Bruno Bischofberger. Substantial parts of three other collections—owned by Arnold Crane, André and Marie-Thérèse Jammes, and Daniel Wolf—were added in a carefully orchestrated effort to shape a major collection within a matter of months. Twelve smaller, more specialized collections made up the rest of the Museum's first holdings, among others those of Seymour Adelman, Michel Auer, Werner Bockelberg, the estate of Ralston Crawford, Krystyna Gmurzynska, Gerd Sander, Wilhelm Schurmann, and Jürgen and Ann Wilde. When finally unpacked and inventoried in Malibu, there were some 25,000 prints, 1,500 daguerreotypes and other cased objects, 475 albums with almost 40,000 mounted photographs, and about 30,000 stereographs and cartes-de-visite. Formed entirely by discerning connoisseurs, the Getty Museum's new collection immediately established it as a major center for the study and exhibition of the art of photography. Since then, hundreds of photographs have been bought each year, broadening and deepening our holdings.

Weston Naef, Curator of Photographs, has worked with a remarkable team during the past decade to organize, catalogue, conserve, exhibit, and publish this vast trove of material. They have presented forty-five exhibitions and prepared twenty books. In their new galleries in the Getty Museum at the Getty Center, which nearly triple the display space they had in Malibu, they can show much more of the collection; in their new Study Room, with large tables and tall windows, they can give more visitors the chance to study works from the vaults. The same curatorial team also assembled this book: Gordon Baldwin, Julian Cox, Michael Hargraves, Judith Keller, Anne Lyden, John McIntyre, and Katherine Ware. For this, and for their successful operation of one of the Museum's most complex departments, I am very grateful.

DEBORAH GRIBBON
Associate Director and Chief Curator

1 WILLIAM HENRY FOX
 TALBOT
 English, 1800–1877
 Nelson's Column,
 Winter 1843–44

 Salt-fixed print from a paper negative
 17 x 21 cm (6¾ x 8⁵⁄₁₆ in.)
 84.XM.478.19

In January 1839, a dream shared by writers and artists for centuries became possible when William Henry Fox Talbot in England and Louis-Jacques-Mandé Daguerre in France disclosed their separately discovered methods of making photographs. Talbot's medium was paper, while Daguerre used plates of silver-coated copper. Talbot was a Cambridge scholar as well as a scientist, having studied physics, botany, and a host of other sciences. When he turned his attention to light and the methods of chemically fixing images in the early 1830s, he developed the idea of a photographic negative capable of producing many positive prints.

Talbot's photograph of Nelson's Column under construction is historical in a political sense. Trafalgar Square was built in honor of the naval victory and death of Admiral Horatio Nelson in the 1805 Battle of Trafalgar off the coast of Spain. The transformation of the square by William Railton's enormous monument—including a bronze, seventeen-foot statue of Nelson at the top of the column—was the subject of bitter popular controversy in the 1840s. Many residents feared it would destroy the view from the steps of the National Gallery looking toward Whitehall. The base of the column caused nearby buildings, such as the prominent Church of St. Martin-in-the-Fields, to be dwarfed by its oversized intrusion. Talbot's photograph endorses the views of those who believed the colossal foundations were "an absolute deformity."

Talbot continued to make pictures of Trafalgar Square over a period of several years. He was a precursor of the modern photojournalist, the first to document events of his day photographically. Of note in this picture are the posters on the hoarding that surrounds the building site plastered near a painted sentence warning that "no bills" should be posted. Talbot incorporated the humor in this juxtaposition into his composition. MH

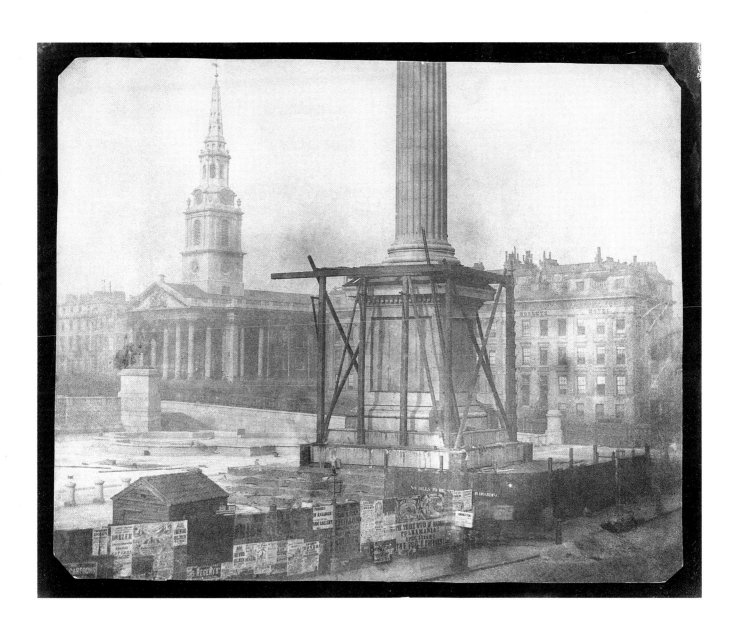

2 ANNA ATKINS
English, 1791–1871
ANN DIXON
English, 1799–1877
Equisetum sylvaticum, 1853
From the album *Cyanotypes
of British and Foreign Ferns*
Cyanotype
25.4 x 20 cm (10 x 7⅞ in.)
84.XO.227.45

Only the sketchiest of details exist about the life of Anna Atkins, one of the first female photographers. Atkins learned the cyanotype process from information sent by its discoverer, Sir John Herschel, to his friend John George Children, who was curator of natural history at the British Museum and Atkins's father. Distinctive because of their blue color, cyanotypes involve the use of iron (rather than silver) salts, which are applied to the paper and subsequently dried in the dark. Placing an object upon the newly sensitized paper and exposing it to direct sunlight creates a photogram, a photograph made without a camera. The resulting image is a detailed silhouette against a brilliant blue (cyan) background, as seen here. Having a keen interest in botany, Atkins embarked on producing cyanotypes of algae and fern specimens that she personally collected.

Immediately recognizing the benefits of the new medium for book illustration, Atkins privately printed and bound her photographs between 1843 and 1853 in the publication *British Algae: Cyanotype Impressions*. Atkins participated in the slow and laborious process of exposing and printing each image in the hand-crafted albums. She was the first person to print a scientific book with pages consisting of actual photographs, each one showing a botanical specimen.

After the death of her father in 1853, Atkins was comforted by her close friend Ann Dixon, who shared her interest in photography. During this time they produced an album of one hundred photographs entitled *Cyanotypes of British and Foreign Ferns*, from which this image is taken. This book was presented to Ann's nephew, Henry Dixon, who was also a photography enthusiast. Like the cyanotypes of algae, these images of ferns are exquisite in their fine detail and rich blue color. *Equisetum sylvaticum* delightfully juxtaposes the ferns: the chaos of the strands on the far right contrasts with the graceful organization of the other stems, which are laid at a gentle angle, curving vertically across the sheet in a way that anticipates art of the twentieth century. Atkins's careful arrangement of the different ferns on the page gives this cyanotype a charm that far exceeds its scientific purpose of specimen identification.

AL

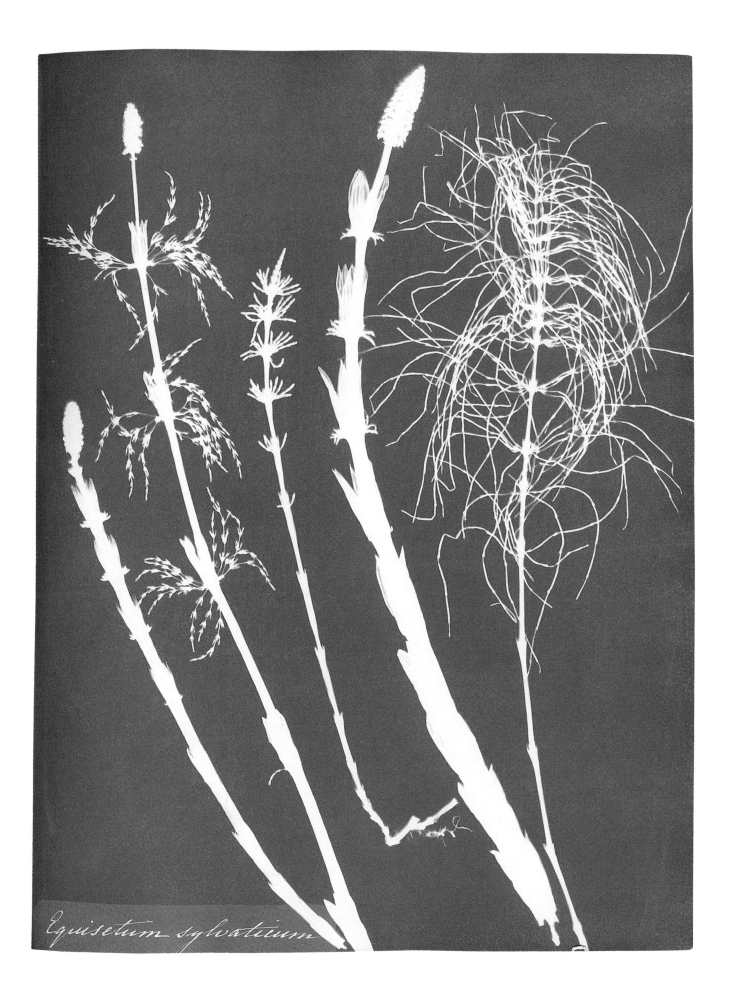

Equisetum sylvaticum

3 DAVID OCTAVIUS HILL
Scottish, 1802–1870

ROBERT ADAMSON
Scottish, 1821–1848
Elizabeth Rigby (Lady Eastlake),
circa 1843–47

Salt print
20.9 x 14.3 cm (8³⁄₁₆ x 5⁵⁄₈ in.)
84.XM.445.21

Shortly after the dawn of photography, the unlikely partnership of the young engineer Robert Adamson with the respected painter David Octavius Hill yielded some of the most important photographs in the history of the medium. At the suggestion of the eminent scientist Sir David Brewster, Hill entered into a working alliance with Adamson, whose photographic studio was in Edinburgh. Using photography to assist him in his large historical painting of the persons involved in the Church of Scotland's 1843 schism, Hill was immediately captivated by the new art form. In the four and a half years before Adamson's untimely death brought an end to the pioneering partnership, Hill and Adamson produced a surprisingly large number of images.

Working in Scotland, and thus not bound by Talbot's English patent, the photographers were free to explore the calotype process. The visible paper fibers in the high-quality watercolor paper Hill and Adamson used for both negatives and prints softened the image and created a painterly effect. Hill commented: "The rough and unequal texture throughout the paper is the main cause of the calotype failing in details before the daguerreotype…and this is the very life of it."

Elizabeth Rigby was an author, critic, and champion of photography. In 1849 she married Sir Charles Eastlake, who became the first president of the Royal Photographic Society. Second only to Hill himself, Elizabeth Rigby was the most popular sitter for these two photographers, appearing in over twenty calotypes. This introspective image of Rigby is tinged with an air of melancholy. With her downcast face, the large cross around her neck, and her tentatively placed gloved hand, she seems to be lost in a state of reverie. Although Hill and Adamson have skillfully composed the scene to appear as an indoor setting, Rigby is leaning against a garden trellis; Hill and Adamson's studio was actually set up outside the house as the picture-making process required strong natural light. The statue of the putti to the left and the book on the table not only act as props for the fictitious interior but also enhance the sitter's contemplative nature and allude to her intellectual abilities as a writer and art critic. AL

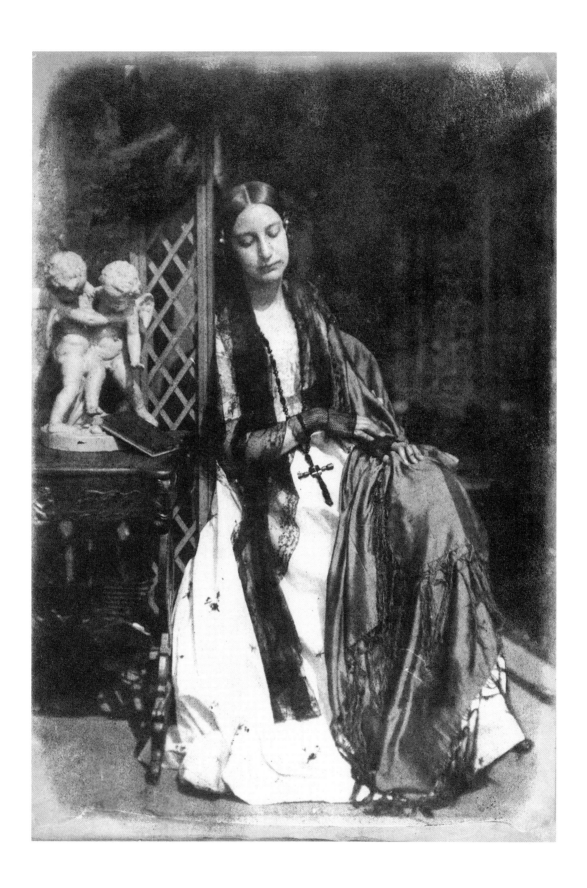

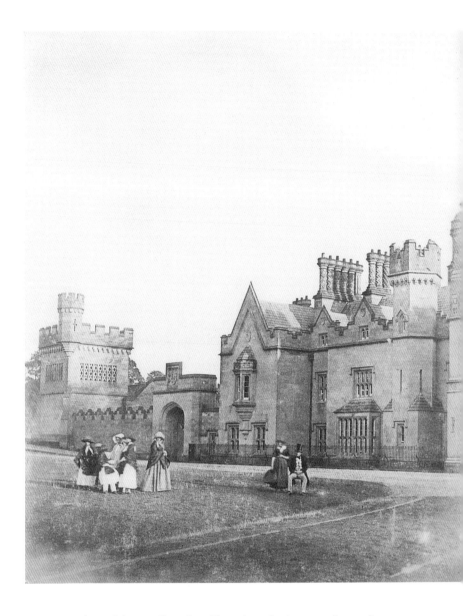

4 CALVERT RICHARD
 JONES
 Welsh, 1804–1877
 Two-Part Panoramic Study
 of Margam Hall with Figures,
 circa 1845

 Salt print from a calotype negative
 Each: 22.5 x 18.6 cm (8⅞ x 7⁵⁄₁₆ in.)
 89.XM.75.1–.2

Calvert Jones was a member of the small circle of friends and relations of one of photography's inventors, William Henry Fox Talbot. Educated at Oxford University and proficient as both a draftsman and a cellist, Jones gained access to Talbot and his discoveries through his close friendship with the inventor's cousin, Christopher Rice Mansel Talbot, a wealthy landowner in south Wales. Jones became a passionate exponent of the calotype after receiving examples sent to him by Talbot in June 1841.

Jones found the most fitting use of the camera to be in the field recording landscape and architecture, as in this study of Margam Hall, the recently completed Tudor-Gothic Revival mansion designed by the architect Thomas Hopper for Christopher Talbot. As a draftsman, Jones was particularly fond of drawing the country homes of his friends, often including figures in the foreground. In this two-part panorama, he arranges the elegantly dressed members of the Talbot and Jones families in discrete

groupings on the estate grounds. Jones has positioned his subjects so as to give due emphasis to the picturesque façade, whose roofline pierces the sky like a jagged series of musical notes. The faintly delineated figures give scale to the architecture and provide a glimpse of the intimate social fabric of the landowning classes of Victorian south Wales.

Dissatisfied with the narrow field of vision of the lenses then in use, Jones was among the first photographers to make panoramic studies from paired negatives. He called them "double pictures"—slightly overlapping exposures joined to harness what he described as the "more perfect and satisfactory representation of many compositions in nature." Jones's comprehension of the potential for the photograph to broaden its frame by a simple and nontechnical procedure reflects his spirit as an artist, continually looking for novel compositions in nature and testing the aesthetic possibilities of the camera against his own vision. JC

Born Jabez Meal in Manchester, England, John Jabez Edwin Mayall became one of the pioneer daguerreotypists in England. Ironically, Queen Victoria mistook the nationality of her own countryman and regular patron, saying "He was the oddest man I ever saw…but an excellent photographer…he is an American." She was not alone in her observation of Mayall's eccentric but charismatic demeanor.

Mayall moved to the United States and began to study photography at the University of Pennsylvania under Professor Hans Martin Boyé around 1844. He expanded the scope of the daguerreotype beyond portraiture with his 1845 panorama of Niagara Falls, which was praised by the painter J. M. W. Turner. At about the same time, Mayall made a series of ten daguerreotypes illustrating the Lord's Prayer, a highly unusual subject for photography. After a successful career in Philadelphia, he returned to England in 1846. There he worked first for the noted London-based French daguerreotypist Antoine-François-Jean Claudet. In the following year he set up his own portrait studio near the noted Adelaide Gallery in London. When the public demand for portraiture began and cartes-de-visite (little pictures mounted on small calling cards) arrived, Mayall became one of the most prosperous photographers in Britain.

Mayall made daguerreotypes of the Crystal Palace at its Hyde Park location, the site of the Great Exhibition, the first international exposition of arts and industry, held in 1851. The exposition was a great success, attracting more than six million visitors during the five months it was opened to the public. The main body of the novel iron, timber, and glass building was 1,848 feet long and 408 feet wide with a 108-foot-high central transept. The structure, consisting of prefabricated iron parts and walls of glass, established an architectural standard for later international fairs. The grandeur of the space and the flooding of sunlight through the glass windows made the juxtapositions of the building's design all the more unusual.

Mayall was known for using large plates that allowed daguerreotypes to show the depth and grand spatial atmosphere the visitors to the exhibition must have felt. The normal daguerreotype was about 2¾ x 3¼ inches; the imperial plate needed a special camera and lens to record the image on the almost 12 x 10-inch plate. This image, and others like it, were acclaimed as technical feats, and it is believed that Mayall produced some of the largest daguerreotypes ever made. MH

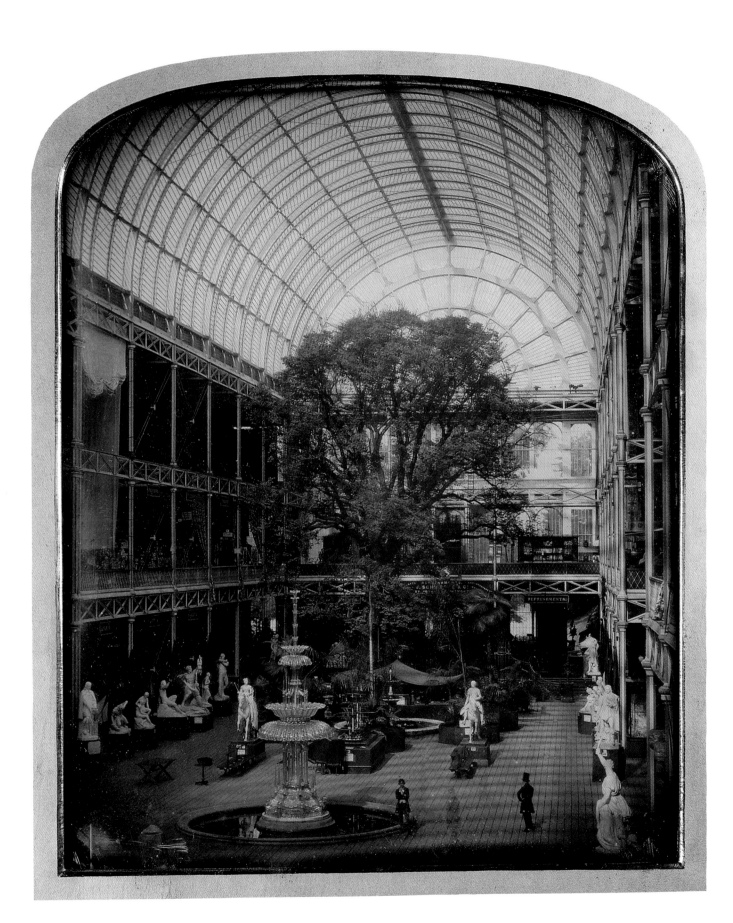

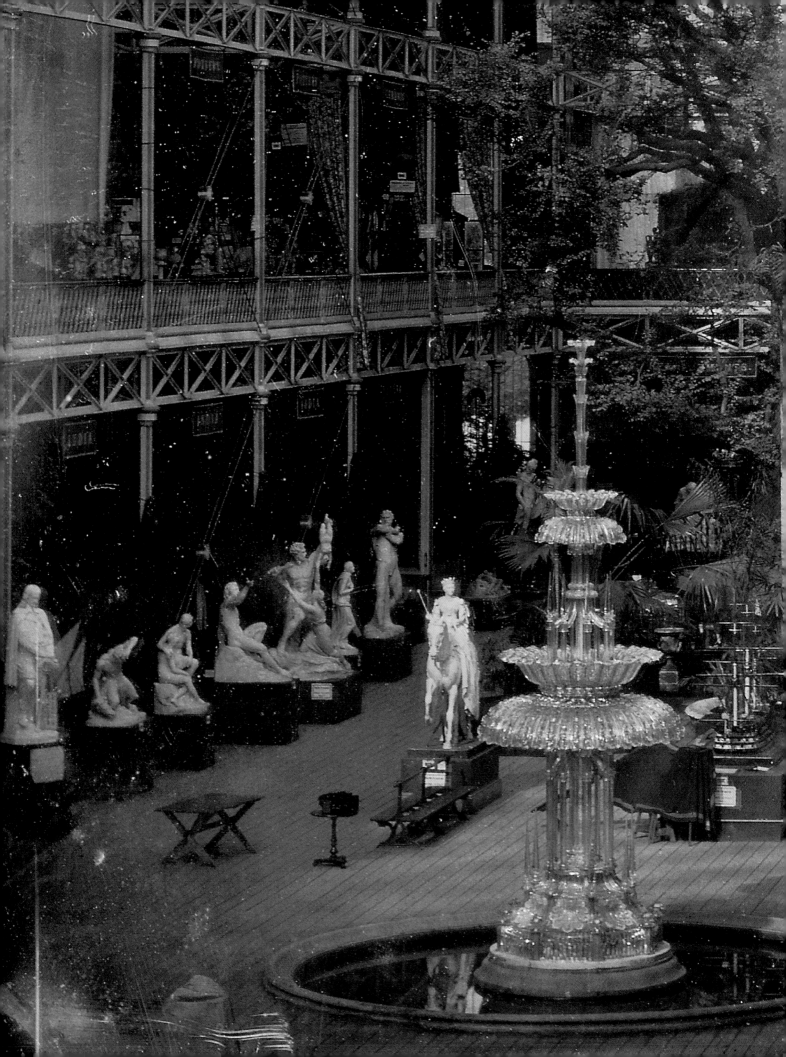

6 ROGER FENTON
English, 1820–1869
*The Valley of the Shadow
of Death*, 1855

Albumen print
27.4 x 34.7 cm (10⅞ x 13¾ in.)
84.XM.504.23

Roger Fenton was the preeminent British photographer of the mid-nineteenth century. Although trained first as a lawyer, then as a painter, by 1852 he had taken up photography. The primary moving force in the establishment of the organization that became the Royal Photographic Society, he was its most frequent contributor, from its first annual exhibition in 1853 until 1862, when Fenton gave up photography. The works he showed were primarily landscapes and architectural studies, which he traveled around England, Wales, and Scotland to make. In 1852, in the course of an expedition to Kiev to record the construction of a bridge, he made the first known photographs of Moscow and St. Petersburg. He was hired by the British Museum in 1854 to document parts of its collections—the first photographer to be regularly employed by a museum. Fenton was eager to have photography equal the artistic accomplishments of the established arts, particularly painting; to this end, in the late 1850s, he made a series of Orientalist genre scenes and still lifes.

Fenton first gained widespread recognition for his photographs of the Crimean War, which he made in 1855 in the Crimean Peninsula on the Black Sea, where England, in alliance with France, the Kingdom of the Two Sicilies, and Turkey, was fighting against Russia. Fenton was commissioned by the Manchester publisher William Agnew to produce a series of images at the front. The expedition was also sponsored by Queen Victoria and Prince Albert, who perhaps thought that his photographs could be used to bolster support for an unpopular war. Because of the era's limitations in photographic technology, Fenton could not capture battle with his camera; instead, he made views of military objectives and camp and battle sites, as well as portraits of officers and groups of soldiers. His work in the Crimea comprised the first large-scale and systematic photographic coverage of war.

The troops called the place where Fenton made this view the Valley of the Shadow of Death because it was frequently raked by Russian cannon fire to prevent British troops from approaching a vulnerable Russian emplacement. Fenton himself came under enemy fire while setting up his camera here but, unruffled, he kept the cannon ball as a souvenir. The Spartan eloquence of this barren landscape littered with spent missiles has rarely been equaled as an expression of the devastation of war. Fenton's negative material, collodion on glass, was oversensitive to blue light, which caused the sky to be overexposed and print as a dead gray mass, heightening the misery-filled emptiness of the scene. GB

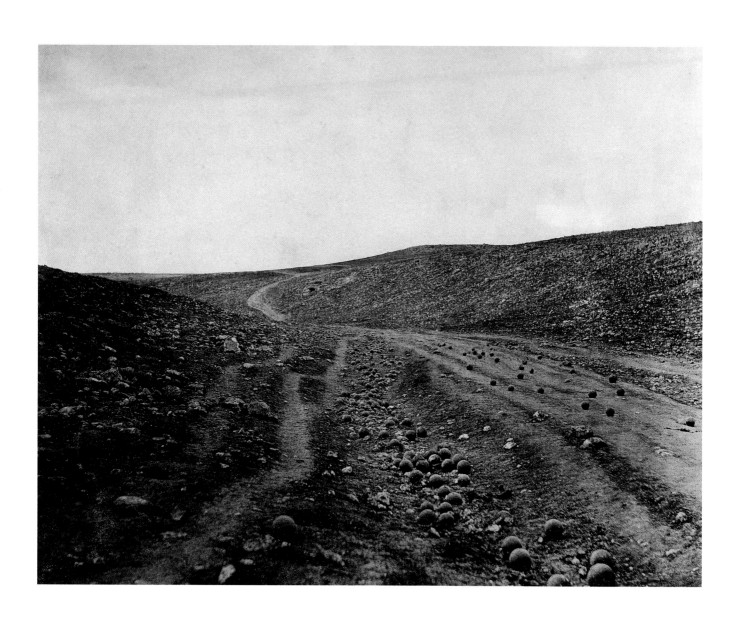

7 JULIA MARGARET
CAMERON
English (born India),
1815–1879
*The Whisper of the Muse/
Portrait of G. F. Watts,*
April 1865

Albumen print
26.1 x 21.5 cm (10¼ x 8⁷⁄₁₆ in.)
84.XZ.186.96

Julia Margaret Cameron began her career in photography at the age of forty-eight after receiving a camera as a gift from her daughter and son-in-law. With the full force of her extraordinary will, Cameron set out to create photographs consistent with the aims of art: "My aspirations are to ennoble Photography and to secure for it the character and uses of High Art by combining the real and Ideal and sacrificing nothing of the Truth by all possible devotion to Poetry and beauty." The wife of a jurist and distinguished legal reformer, Cameron moved in the highest circles of society in Victorian England. She was related by blood, friendship, and social ties to many influential people and she used this intricate support system to help advance the following for her art.

Cameron drew many of the subjects she photographed from within her extended circle of family and friends. George Frederick Watts (1817–1904), one of the leading painters of the day, sat for her on many occasions. An indefatigable theorist and proselytizer, Watts was an artistic missionary who sought to improve the condition of mankind through his art. His vision of creating a Victorian pantheon that could transcend the age was one he shared with Cameron.

In this photograph, Cameron casts Watts in the role of a musician inspired by his muse, played by a dark-haired girl who looks intently over his shoulder. Bow in hand, he turns his gaze upon the figure of the other child, whose head is daringly truncated at the left edge of the frame. This study is remarkable for the sophistication of its surface elements, which are skillfully arranged in a tightly compressed space. The scrolling shape of the violin, the folds of Watts's cape and waistcoat, his beard and the girl's flowing mane of hair are woven together to create a composition of taut, concentrated energy. Cameron recognized that inspiration was integral to artistic endeavor, and her inscription on the mount under this image—"a Triumph!"—indicates the degree to which she felt this photograph captured that spirit. JC

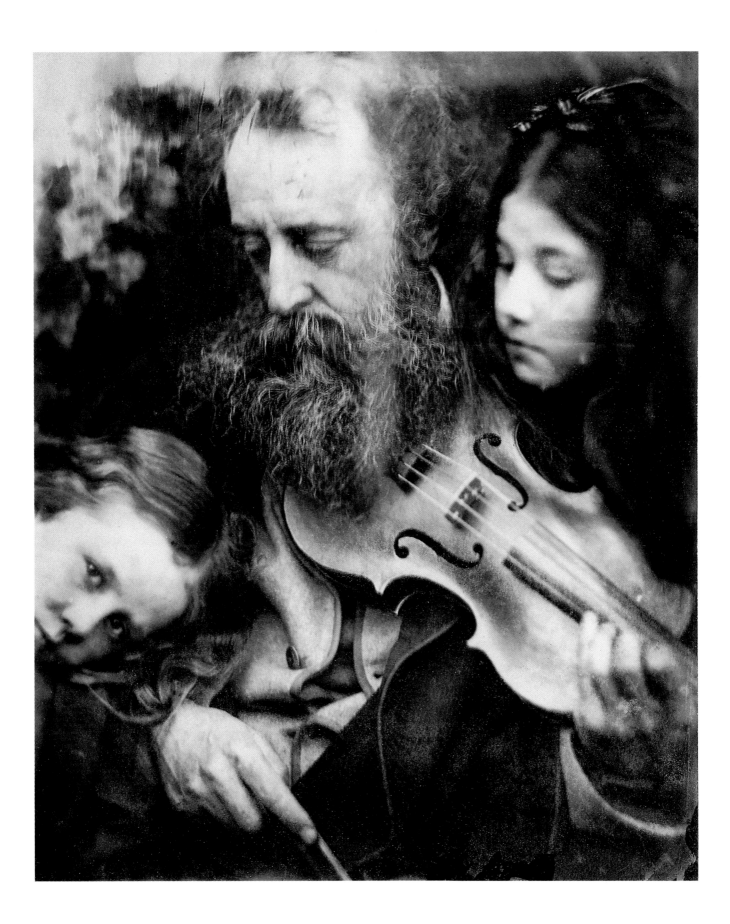

8 DR. HUGH WELCH
 DIAMOND
 English, 1809–1886
 Seated Woman with Bird,
 circa 1855

 Albumen print
 19.1 x 13.8 cm (7½ x 5⁷⁄₁₆ in.)
 84.XP.927.3

Hugh Welch Diamond began working in the medium of photography three months after Talbot introduced his photogenic drawing process in 1839 (see no. 1). Diamond had embarked upon a career in medicine, with a particular interest in psychiatry and mental illness, before engaging in photography. His talent was recognized by fellow photographer Henry Peach Robinson, who later remarked that the doctor was "undoubtedly, the central figure in Photography." In 1848, he became the resident superintendent of the Female Department of the Surrey County Lunatic Asylum, a position he held for ten years. During this time Diamond used photography in his research into insanity.

Explorations into human physiognomy were very popular in the late eighteenth and nineteenth centuries. In 1838, Alexander Morison proposed in *The Physiognomy of Mental Diseases* that there was a correlation between a person's appearance and their psychopathology. Years later, in 1856, Diamond illustrated this theory with his photographs in a paper entitled "On the Application of Photography to the Physiognomic and Mental Phenomena of Insanity." These photographs of female inmates in the Surrey Asylum gave Diamond a record of the patient's facial expressions to study and also served the institution's administrative purposes by identifying the patient.

In this photograph, the woman's face is at once captivating. Set against a drab background and wearing plain clothes, she stares out and beyond the camera. Her calm expression belies the anxiety visible in her eyes. There is a feeling of deep pathos as she tenderly cradles a dead bird in her hands. The bird is symbolic of the captivity and loss undoubtedly experienced by the woman, who, because of mental illness, is confined to an asylum. For reasons unknown, Diamond ceased taking photographs of his patients in 1858, after an incident caused him to leave the Surrey Asylum and set up his own private institution. AL

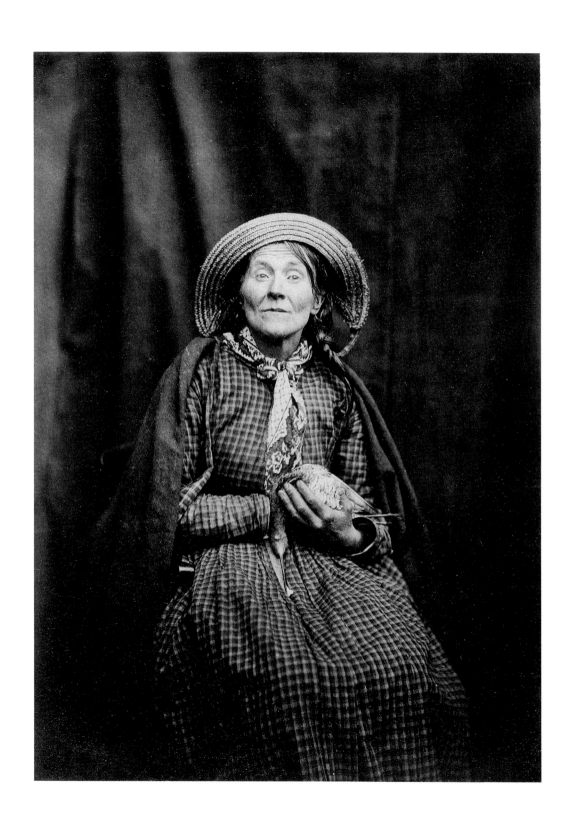

9　ROBERT MACPHERSON
English (active Italy),
1815–1872
The Campagna near Rome,
1850s

Albumen print
22.1 x 38.8 cm (8¹¹⁄₁₆ x 15¼ in.)
84.XO.1378.24

Robert MacPherson, a Scottish surgeon, settled in Rome in 1840 and took up the study of painting. When a friend from Edinburgh, a Dr. Clark, arrived in Rome with a camera in 1851, MacPherson took up photography himself while helping Clark learn to make photographs. The studies MacPherson produced of Roman buildings and the views he made outside that city in the following twenty years are among the most distinguished architectural productions of the nineteenth century.

His subject in this example is the staccato rhythm of the crumbling remains of the Claudian aqueduct marching across the horizon toward the city of Rome, whose walls lie four miles away. Designed to bring water to the city, the aqueduct was begun by the emperor Caligula and finished by Claudius in A.D. 49. Made of poured concrete and faced with stone, it ran for forty-one miles, of which nine and a half were above ground—often swampy and malarial ground. In MacPherson's day the open countryside called the Campagna ran right to the city walls and was thought to epitomize romantic desolation.

MacPherson's view out over a marshy declivity and toward the aqueduct exhibits his acute sense of how to marshal pictorial elements to produce a strong and elegant composition. In the left foreground a strand of boundary fences leads the eye toward the center of the picture, where a line of trees and more solid fences along an elbow of the ancient Via Appia take the eye further into the distance, up to a group of rustic, sun-struck farm buildings. The miasmic atmosphere can be sensed in the haze that veils the distant hills.

MacPherson's occasional use of circular or elliptical formats to intensify a central subject echoes the shapes of some landscape paintings of the period. He was one of the first photographers to make pictures designed to appeal to travelers—some of whom, like John Ruskin and Henry James, went on morning horseback rides across the land shown here. Tourists could purchase MacPherson's photographs at his commercial establishment in the heart of Rome near the Piazza di Spagna. His studio was thus a forerunner of the modern postcard vendor's stall in Rome, but without a formulaic product to purvey.　　　　　　　　　　　　　　　　GB

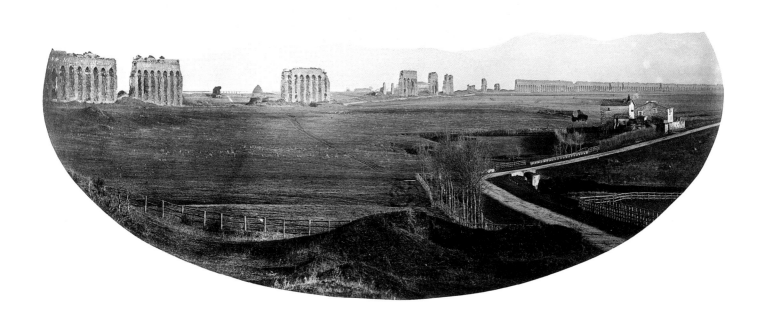

10 HIPPOLYTE BAYARD
French, 1801–1887
Self-Portrait in the Garden, 1847

Salt-fixed print from a paper negative
16.5 x 12.3 cm (6⁹⁄₁₆ x 4¹³⁄₁₆ in.)
84.XO.968.166

Based on experiments that he began on January 20, 1839, in his spare time (he held a full-time position with the French government), Hippolyte Bayard succeeded in creating images on paper; in the same year, separate discoveries of photographic techniques were announced by Daguerre in France and by Talbot in England (see no. 1). Talbot, Daguerre, and Bayard each claimed credit for the invention, which has resulted in some confusion about who did what when.

Bayard occupies a key position in the early history of photography for the series of superb self-portraits he made between 1839 and 1863. This image of 1847 is one of two Bayard self-portraits in the Getty Museum. Here, he presents himself with the accouterments of a gardener—plants, a watering can, clay pots, a barrel, a vase, and a trellis on which a young vine is growing. Bayard gathered and arranged these objects for the purpose of being photographed; five years earlier, he had created a still-life arrangement with gardening implements that now exists only in the form of a paper negative. Bayard subtly reveals his personality by his cap, which is pulled to a jaunty angle over his right eyebrow, and by his left thumb latched to his waistband.

Neither Daguerre nor Talbot made any self-portraits and rarely even allowed themselves to be portrayed by other photographers. By being the first to explore various facets of his character through his work, Bayard made photographic history. Here, he surrounds himself not with the artifacts of political power or with symbols of wealth, but with commonplace objects. In visual language he tells us, "I am a gardener as well as an artist." In making this visual confession, he forever changed photography by introducing the first-person voice. WN

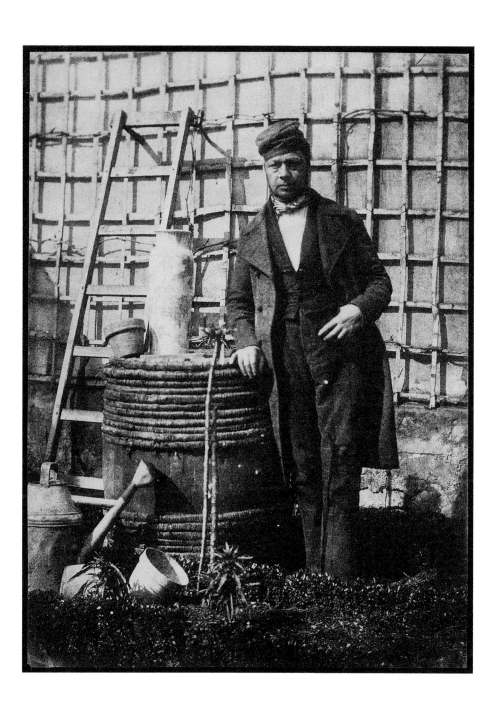

11 NADAR
(Gaspard-Félix Tournachon)
French, 1820–1910
Self-Portrait, circa 1854–55

Salt print
20.5 x 17 cm (8$\frac{1}{16}$ x 6$\frac{11}{16}$ in.)
84.XM.436.2

"Nadar" is derived from the artist's nickname, "Tourne à dard" (a play of words on his family name, Tournachon). Nadar took up photography in 1854 and was soon proficient enough to establish a studio in his home on the rue St. Lazare in Paris, where he photographed friends and family; at the same time he continued his vocation as a caricaturist. The two types of pictures could not be more different. Caricature depends for its success on exaggeration and simplification, while portrait photographs are more complex and truthful depictions. To achieve this, Nadar placed his subjects against a neutral cloth backdrop with gentle light falling from above and the side. "Natural" seems the best word to describe Nadar's portrait photographs; his subjects usually appear to have been caught at the moment they walked in the door to his studio. This style is opposite to the barbed exaggeration that gave Nadar his name and first fame.

With his thick shock of red hair and exceptionally free spirit that rejected the mores of middle-class society, Nadar was the epitome of the Romantic Bohemian. He frequented the same cafés and studios made famous in Henri Murger's book *Scènes de la vie de Bohème* (Paris, 1851), which chronicles the loves, studies, amusements, and sufferings of a group of impecunious students, artists, and writers in a semi-documentary, literary style.

During his first year as a photographer, Nadar made a series of self-portraits as well as studies of his wife and children, following a solid tradition of artists using themselves and their families as models. Since automatic exposure had not yet been invented, this portrait may have been made with the assistance of his brother, Adrien Tournachon, or of Nadar's new wife, Ernestine. Nadar gazes directly out at the viewer. Although his eyes are mostly in shadow, the intensity of his gaze is arresting; so, too, is his thick, ungroomed hair that almost touches his shoulders. His right hand, closed nearly to a fist, supports his head at the cheek and jaw. His left fingers are spread apart; the last two give the illusion of being amputated at the middle joint. Nadar does not flatter himself in this picture, but rather suggests that he is a volatile man with a dark side. WN

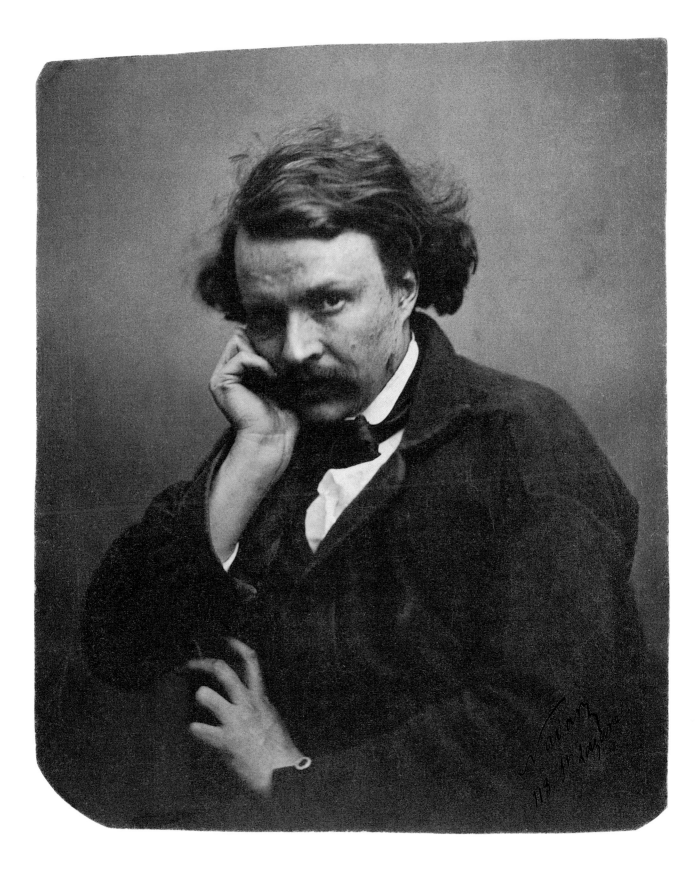

12 GUSTAVE LE GRAY
French, 1820–1883
Seascape with Sailing Ship and Tugboat, circa 1857

Albumen print
30.2 x 41.3 cm (11⅞ x 16¼ in.)
86.XM.604

Detail overleaf

Gustave Le Gray's meteoric career in photography effectively lasted about twelve years, from his sudden appearance as a photographer at the end of the 1840s, through his dazzling preeminence in the mid-1850s, to his abrupt disappearance from Europe at the end of 1860. In this brief period, he created an enduring legacy as a technical innovator, an author of an influential handbook on photography, and a teacher of other well-known photographers. The breadth of his subject material ranged from architectural studies of medieval buildings and newly built Parisian landmarks to landscapes in the forest of Fontainebleau, and from portraiture to documentation of the military life of the troops of Napoleon III. The extraordinary quality and variety of light in his images are admired to this day.

Among his best-known works are the series of striking seascapes he began about 1855. These are generally characterized by their broad effects created with minimal compositional elements, principally water and sky. This photograph perfectly encapsulates the age of sail giving way to the age of steam, whether the tugboat is, in fact, towing the sailing ship or simply leaving it behind in a wake of smoke and water. Capturing this fugitive effect required a very short exposure time and a single negative, rather than the two Le Gray sometimes employed for seascapes, in which he used one for the sky and the other for the sea. The juxtaposition of small-scale, silhouetted vessels along the horizon with the broad swaths of water and air emphasizes the comparative frailty of human effort against the natural elements. Horizontal layering is an essential component of these seascapes.

Le Gray spent the end of his life in Egypt as a drawing teacher at a technical academy under the direct patronage of the viceroy. He continued sporadically to make photographs, but apparently few of these later images have survived. GB

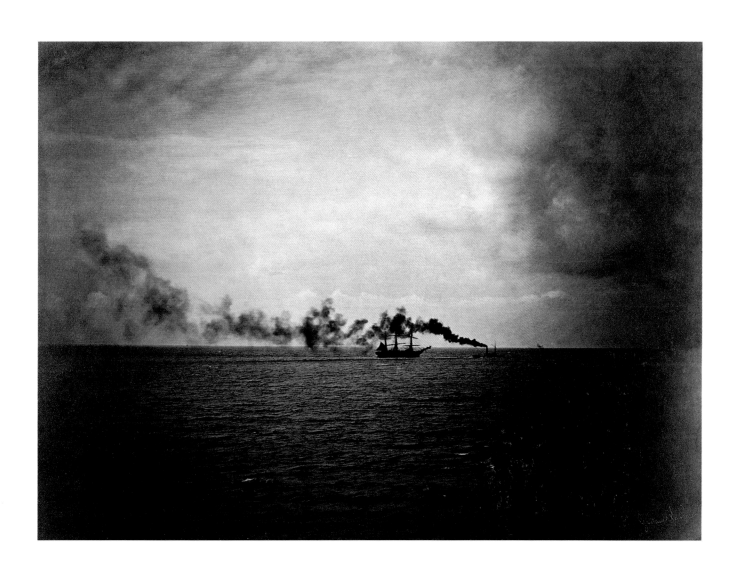

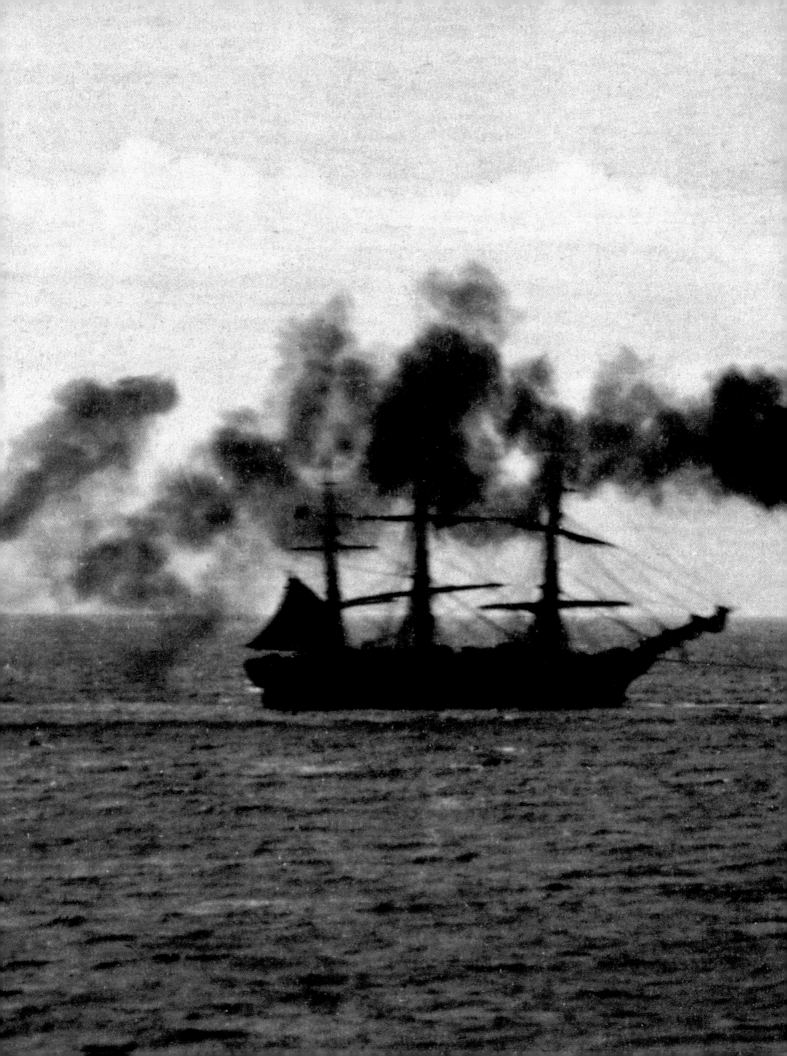

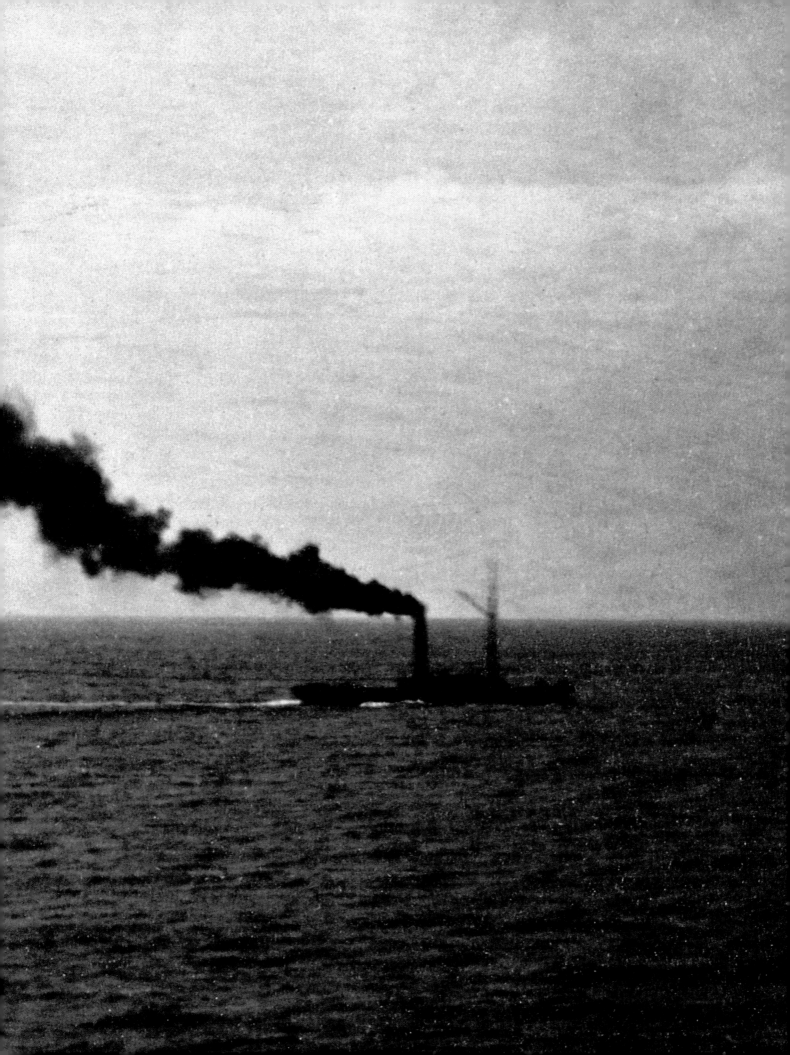

13 HENRI LE SECQ
French, 1818–1882
Tower of the Kings at Rheims,
1851

Salt print
35.2 x 26 cm (13 13/16 x 10 3/16 in.)
84.XP.370.25

Trained as a painter in the studio of Paul Delaroche in Paris, Henri Le Secq began working in the medium of photography in the early 1850s. During this time, French photographers excelled in the use of the paper negative. The Emperor of France, Louis-Napoléon, initiated projects that were instrumental in engendering a sense of pride in the country and strengthening the idea of a French nation. Among these was the Mission Héliographique, a photographic survey of the historic architecture of France outside Paris. The Commission des Monuments Historiques selected Le Secq to be one of the survey's photographers. (Other photographers participating in this notable project included Gustave Le Gray, Edouard-Denis Baldus, and O. Mestral.) The landscape of France, with its monuments and ruins, was promoted as the ideal; while in the cities, urban renovations cleared the way for a modern society. Le Secq reflects this dichotomy of old and new in his work: the subject is an ancient monument, but he provides what may be considered a modern interpretation of it.

In this photograph, Le Secq shows a detail of the Tower of the Kings (*Tour des Rois*) of the Cathedral of Notre Dame in Rheims. The cathedral dates from the thirteenth century and was the traditional coronation site for French kings until 1830. The statues in the arcade are all portraits of early French monarchs. By choosing his viewpoint high above the ground and directly facing the tower, Le Secq not only draws the viewer's attention to the cathedral's historical importance but also creates a striking image. The precarious wooden structure of the scaffolding on the left is juxtaposed with the solid stone blocks and detailed carvings of the cathedral. A bold composition, the photograph presents a fragment of a greater whole. By focusing on one section of the cathedral, Le Secq fills the entire frame with architectural detail, causing the image to appear flattened (note the distinct lack of foreground and background) and giving it a decorative quality. With its out-of-focus foreground and multitude of accidental details, the work is not organized according to the traditional rules of composition; instead, it is a dynamic arrangement full of conflicting forces whose visual drama surprises and delights the eye. AL

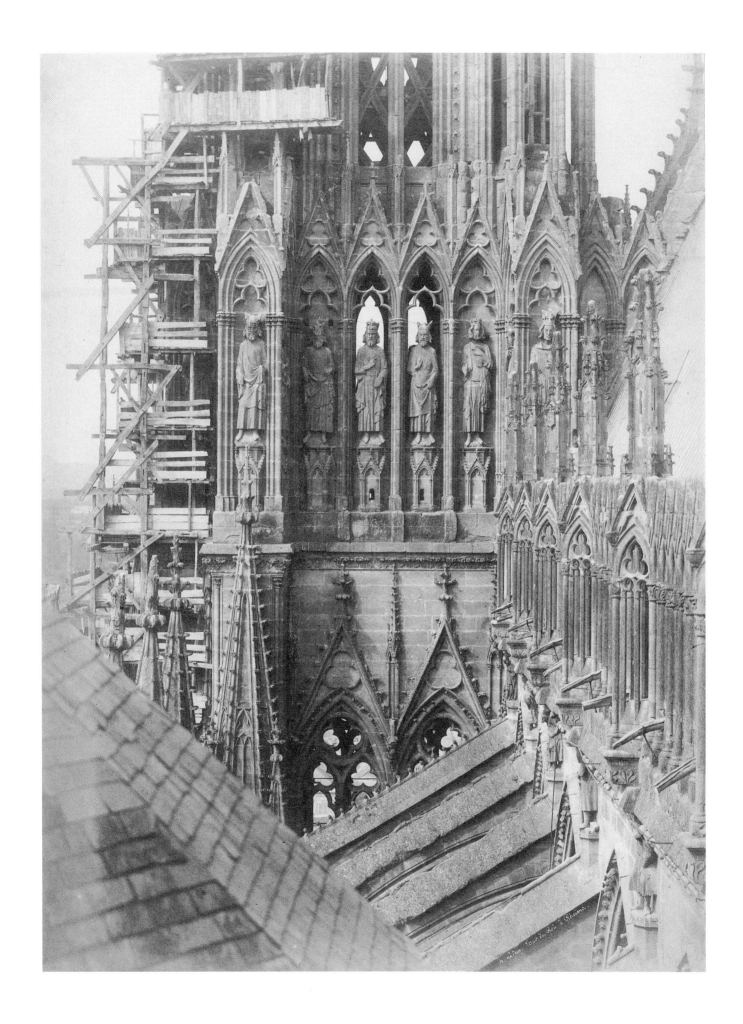

14 CHARLES MARVILLE
French, 1816–1879
The Impasse de l'Essai at the Horse Market, Paris,
negative 1860s; print after 1871

Albumen print
26.2 x 37.1 cm (10⁵⁄₁₆ x 14⁵⁄₈ in.)
84.XM.346.14

Charles Marville, one of the great photographic documentarians of Second Empire Paris (1852–1870), developed his acute powers of observation and composition during the almost twenty years he spent as a designer of wood-engraved illustrations for books and popular magazines. When he took up photography in the early 1850s, working as a traveling photographer for the thriving concern of Blanquart-Evrard, Marville assuredly understood that photographs of architecture and landscape above all depend on the skillful handling of light and space. Moreover, his extraordinary facility in the photographic techniques of his day—initially the calotype and later the wet collodion process—enabled him to achieve consistently excellent results.

When Baron Haussmann became prefect of the Seine district of Paris in 1853, one of his first acts was to commission a team of photographers—including Baldus, Le Secq, and Marville—to record the city prior to his massive reconstruction of its streets and public spaces. Marville worked meticulously and according to the prefect's plan, photographing streets and locales that would soon be leveled to make way for the projected new boulevards. One of the areas scheduled for demolition was the Horse Market and its environs, an important trading place in Paris at a time when horses and mules were the primary means of transportation.

This study of a cul-de-sac (*impasse*) behind the Horse Market illustrates the obstacles and irregularities of the old Paris streets that Haussmann was aiming to replace with light, airy boulevards. The relatively low, axial placement of Marville's camera accentuates the variety of structures and sight lines that comprise the scene. Stripped of their foliage, the trees on the left cantilever across the foreground, simultaneously guarding the space and leading the eye into the recesses of this shabby, timeworn neighborhood. Marville reveals a sensitivity to the varying textures before his lens, from the weathered cobblestone pavement to the rain-eroded dirt alley and crumbling stucco façades. The descriptive clarity of the image is matched by Marville's skillful orchestration of the alternating patterns of light and dark, through which he reveals himself as a master of pictorial form. JC

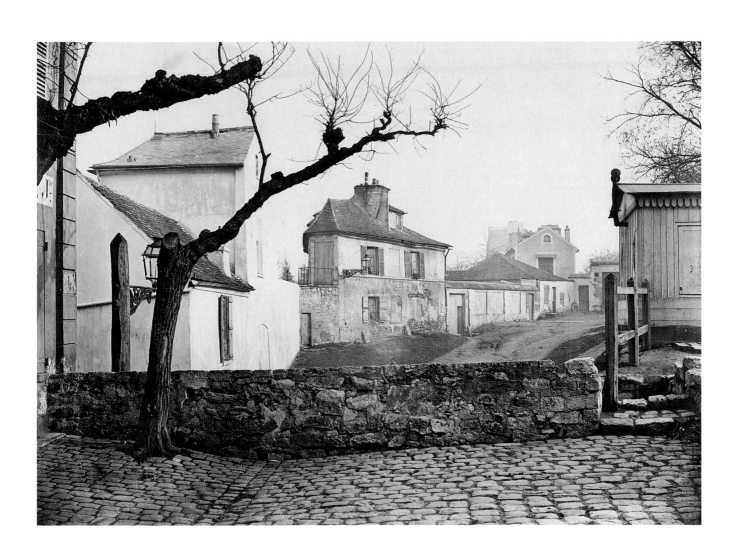

15 CAMILLE SILVY
French, 1834–1910
River Scene—La Vallée de l'Huisne, negative 1858; print 1860s

Albumen print
25.7 x 35.6 cm (10⅛ x 14 in.)
90.XM.63

Before taking up photography, Camille Silvy had studied law and become a professional diplomat; thus, photography was at first merely a hobby to him. After traveling to Algeria in 1857 with his drawing master, and being disappointed with his own drawings, he asked his friend Count Olympe Aguado to teach him photography. Silvy became so dedicated to the art that he joined the Société Française de Photographie. One of his first subjects was the landscape around his birthplace, the village of Nogent-le-Rotrou on the Huisne River. Just a handful of these landscape studies have survived; however, none are as brilliant in scope and detail as the *River Scene* reproduced here. It exists in just four prints, each one different from the others in important respects, especially in the sky and surface texture. (The four prints were exhibited together for the first time in an exhibition at the Getty Museum, Malibu, in 1993.) "The natural beauty of the scene itself, rich in exquisite and varied detail, with the broad, soft shadows stealing over the whole, produce a picture which for calm, inviting beauty we have not seen equalled," a critic wrote in 1859.

A highly precocious student, Silvy created this masterpiece relatively early in his photographic career. He sent a print to the 1858 exhibition of the Royal Photographic Society in London, where its great merit was immediately recognized. The image was described by one commentator as "perhaps the gem of the whole exhibition." Another writer noted, "It is impossible to compose with more artistry and taste than M. Silvy has done…in which one does not know whether to admire more the profound sentiment of the composition or the perfection of the details."

This photograph was taken from the Pont de Bois, a bridge over the Huisne River located a few minutes' walk from the house where Silvy was born. The river provided power for mills that benefited the small community and produced the economic freedom for landowners such as Silvy's family. His wealth allowed him to pursue a profession as financially unrewarding as photography.

However, Silvy surprised his family by moving in 1859 to London, where he established a portrait studio and became one of the most successful portraitists to high society in the city. He specialized in fastidiously composed, miniature carte-de-visite portraits that were made with a sense of perfection in the skillful way he posed and lighted his sitters and dressed the setting. WN

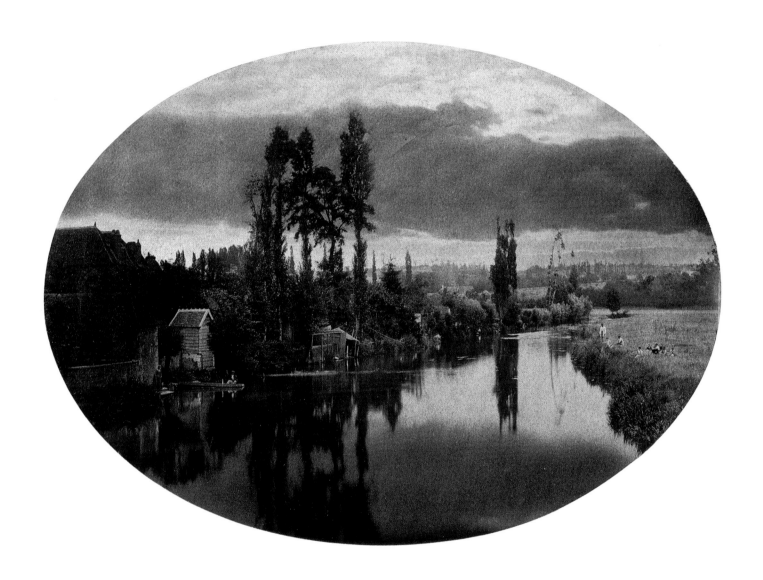

16 UNKNOWN
PHOTOGRAPHER
American, active mid-
nineteenth century
Portrait of Edgar Allan Poe,
late May or early June 1849

Half-plate daguerreotype
12.2 x 8.9 cm (4¹³/₁₆ x 3½ in.)
84.XT.957

A tragic figure in American literary history, Edgar Allan Poe (1809–1849) possessed a great intellect and a melancholy heart. A poet, writer, editor, and critic, he is most famous for his tales of the macabre and great mystery stories. In this portrait, Poe seems to gaze out at the world in a near-stupor. The camera's glass eye captures the curling strands of hair in jewel-like precision above his wide, furrowed brow and the minute detail of the small scar beside his left eye; it also records with great candor the outward signs of a sick man. The writer's puffy skin, baggy eyes, and drooping mouth presage his untimely death about four months later. The image is like a death mask: his visage and faraway eyes belong to a man who appears to have seen death in many incarnations.

Annie Richmond, with whom Poe cultivated a friendship and an eventual affair following his wife's death, arranged for the sitting and is thought to have paid for at least two portraits. The surviving image is thus known among Poe scholars as the "Annie" daguerreotype. Of this likeness, Poe observed, "My life seems wasted—the future looks a dreary blank."

At least eight known daguerreotype portraits of the poet have survived. Poe himself perceived Daguerre's invention as nothing short of miraculous. In January 1840 he wrote, "The instrument itself must undoubtedly be regarded as the most important, and perhaps most extraordinary triumph of modern science…. All language must fall short in conveying any just idea of the truth…. For, in truth, the Daguerreotype plate is infinitely…more accurate in its representation than any painting by human hands."

The list of photographers who may have made this portrait of Poe has grown to more than a dozen. However, it is most likely that it was made by George C. Gilchrist, the most prominent of the Lowell, Massachusetts, daguerreotypists. Gilchrist practiced his art from 1847 until after 1860 and made portrait photographs of many eminent personalities.

MH

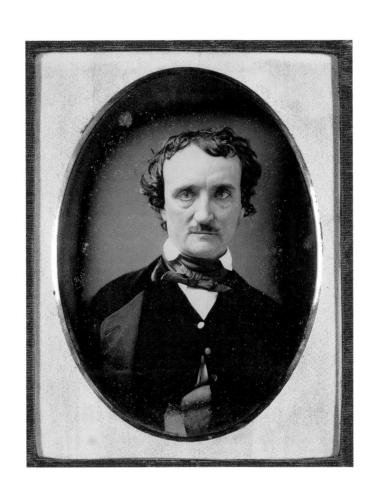

17 JOHN PLUMBE, JR.
American (born Wales),
1809–1857
The United States Capitol, 1846

Half-plate daguerreotype
17 x 21 cm (6¾ x 8⁵⁄₁₆ in.)
96.XT.62

John Plumbe, Jr., a Welshman by birth, came to the United States at the age of twelve. He became a civil engineer, pioneering railroad development across the West, and has been widely credited with originating the idea of a transcontinental railroad. Later, when both work and money became scarce, Plumbe's fascination with architecture and the new art form of the daguerreotype led him to a new profession. Plumbe became acquainted with the medium in 1840 after seeing experimental images by itinerant photographers who were displaying their daguerreotypes to the public. He was so successful that he soon owned photographic studios in thirteen cities, including one in Washington, D.C.

This daguerreotype shows an oblique view of the east front of the United States Capitol. The Capitol, in 1846, was a relatively simple building, but one that had gone through four successive architects: William Thornton, Benjamin Henry Latrobe, Charles Bulfinch, and Robert Mills. The original building, begun in 1791, took thirty-four years to construct. The wings, which housed both the Senate and the House of Representatives in Plumbe's day, now connect the present chambers with the central rotunda. This image is one of three daguerreotype views Plumbe made of the building at the same time that he was photographing the principal government buildings in the nation's capital, including the President's House (now called the White House), the U.S. Patent Office, and the General Post Office. The President's House is faintly visible at the far upper left in this daguerreotype. Thus, in a single view, Plumbe was able to depict the underlying organization and symbolic content of Washington, D.C., with the Capitol at the center of the city and the White House separated from it at the other end of Pennsylvania Avenue.

When the failure of his chain of photographic galleries forced him into bankruptcy, Plumbe retired to Dubuque, Iowa. An unsuccessful attempt to recover his fortune in the California gold rush finally drove him to suicide in 1857. MH

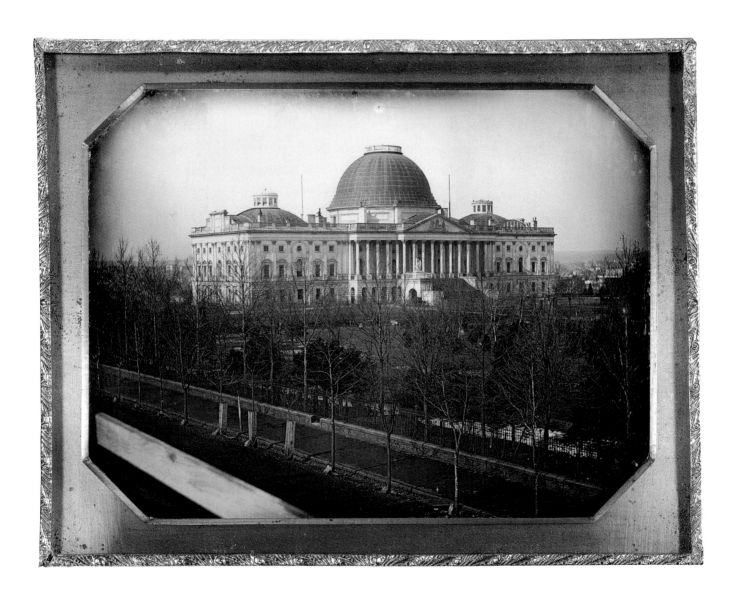

18 ALBERT SANDS
 SOUTHWORTH
 American, 1811–1894

 JOSIAH JOHNSON
 HAWES
 American, 1808–1901
 *Early Operation Using Ether
 for Anesthesia*, 1847

 Whole-plate daguerreotype
 14.6 x 19.9 cm (5¾ x 7⅞ in.)
 84.XT.958

Albert Southworth and Josiah Hawes each came to photography independently through attending lectures and demonstrations given in the spring of 1840 by Jean-François Gouraud, who had learned the process from Daguerre himself. Southworth established a respected portrait studio in Boston in partnership with Joseph Pennell, who was succeeded by Hawes in 1843. In their studio, located on Tremont Row, Southworth and Hawes became famous for their daguerreotypes of socially prominent Bostonians as well as visiting politicians and theatrical celebrities.

Constantly experimenting with new methods, they charged patrons at the top of the scale: Mathew Brady in New York, perhaps the era's foremost portraitist, received $2.00 for a sixth-plate daguerreotype, while the same size from Southworth and Hawes cost $5.00. Types of work other than portraiture—city views, landscapes, public events, and large groups of people—were very time-consuming to create and were not profitable.

Long before the camera could easily be used to record historical events, Southworth and Hawes did so in 1847 in *Early Operation Using Ether for Anesthesia*. The first public demonstration of the use of ether for anesthetizing patients during surgery took place in October 1846 in the teaching amphitheater of the Massachusetts General Hospital, but no photographer was present for the historic moment. In the following weeks and months other demonstrations of surgery using ether took place, including the one recorded here, in which Dr. Solomon Davis Townsend is about to perform the surgery. The vivid reality of the image is startling: surgical instruments housed in glass-fronted cases at the rear of the room, the accouterments of surgery on the table, the frock coats the doctors wear, and the socks still on the patient's feet are all telling details. WN

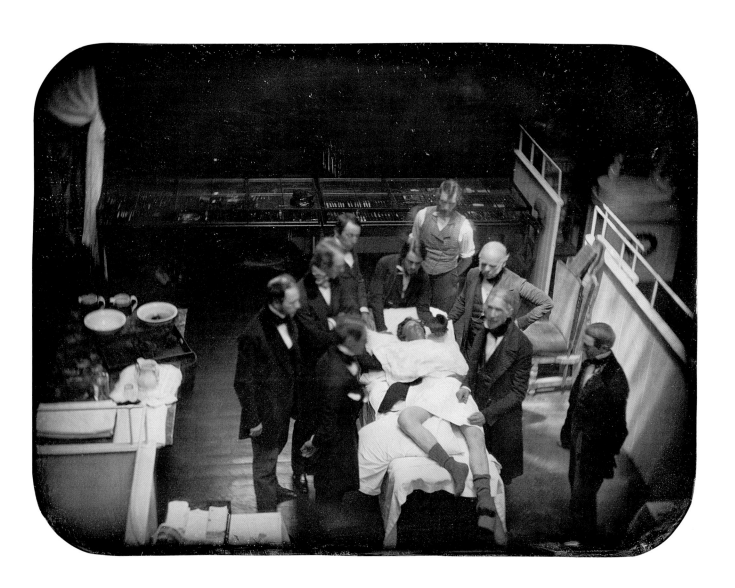

19 JOHN BEASLEY GREENE
American (active Egypt
and Algeria), 1832–1856
The Temple of Luxor,
1853 or 1854

Salt print
23.4 x 29.2 cm (9¼ x 11½ in.)
84.XM.361.2

J. B. Greene, the son of an American banker working in Paris, devoted the end of his brief life to photography. Greene made some of the earliest and most poetic images of Egypt, to which he probably traveled for the sake of his health. Like all tourists then, and many now, he moved from place to place in Egypt along its central highway, the River Nile.

This longitudinal view of the great temple at Luxor was made from the west, the river side of the complex whose main axis is parallel to the Nile. The fibers of the paper negative that Greene used to make this print show through, enhancing the soft texture of the foreground subject, the alluvial plain that flooded annually, and contributing to the effect of shimmering heat that seems to emanate from the photograph. The boat on which Greene arrived, which also served as his darkroom, must be lying close behind the camera, although the river's edge is not visible. This, then, may be the first view Greene had of the temple complex; he must have recognized the subtle beauty of the scene and how it would translate into the purplish grays of the finished print.

The processional colonnade of massive columns in the center of the image was originally intended by their builder, Amenhotep III (reigned 1386–1349 B.C.), to form part of a hypostyle hall, which was never completed. To the right the complex continues with a courtyard of less grandiose proportions built by the same eighteenth-dynasty pharaoh, and beyond it at the farthest right lies an older portion of the building that contained the sanctuary and terminated the complex. To the left of center (indistinct in Greene's picture) lie another columned courtyard and a set of massive pylons. The lone palm tree, whose fronds have swayed in a breeze during the course of the long exposure, is ephemeral by comparison with the hulking, static architecture beyond. No other life stirs here. Greene's stark view of the monumental architecture emphasizes its isolation between river and desert, banded above and below by sky and sand. GB

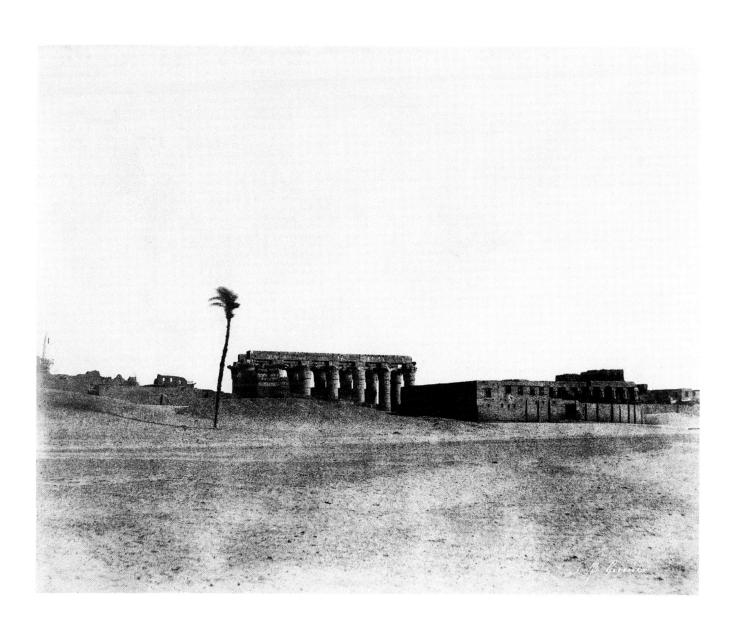

20 WILLIAM H. BELL
American (born England),
1830–1910
*Perched Rock, Rocker Creek,
Arizona*, 1872
From the album *Geographical
and Geological Explorations
and Surveys West of the 100th
Meridian, 1871–73*

Albumen print
27.5 x 20.3 cm (10¾ x 8 in.)
84.XO.1371.30

This photograph was made in 1872 during a U.S. Government Survey expedition of the area west of the one hundredth meridian led by Lieutenant George M. Wheeler. Bell served as the expedition's photographer; his work was used to illustrate the final report of the team's findings and was also sold to the public in the form of stereographs. Bell confronts us with the astounding bulk and density of this rock formation by placing it in the center of the composition and allowing it to fill nearly the entire picture. The caption to the stereograph version of this image (also in the Getty collection) indicates that his primary objective was to emphasize the effects of erosion at the base of the formation. However, in so starkly isolating the rock for this purpose, Bell also reveals his admiration of its appealing form, immense and immobile, whittled by the forces of mere air that may someday send it toppling. This close-up technique also presents us with the opportunity to examine the surface of the rock in great detail, looking to divine personality through physiognomy just as we might do with a portrait.

Bell directs our attention to the pocked surface of the sandstone so successfully that we hardly notice the man seated in its shadow. Human figures were often included in nineteenth-century photographs of colossal natural wonders to provide a sense of scale; however, this figure ignores his duties in that regard, and indeed, turns his attention away from the rock to examine the ground below with a magnifying glass. It is hard to imagine that this juxtaposition is accidental. The result is the somewhat humorous scenario of a man so completely absorbed in his work that he seems oblivious to the boulder towering over him.

Although he was born in Liverpool, Bell grew up in Philadelphia, where he set up a photography studio in 1848 and became an active contributor to the journal *Philadelphia Photographer,* sharing his ideas on technical improvements for the medium and his results in field-testing equipment and materials during his travels. Bell was a Union soldier in the Civil War and fought at the battles of Antietam and Gettysburg. In 1865 he was appointed chief photographer of the Army Medical Museum in Washington. His extensive photographic record of the wounds of Civil War soldiers was used to share case histories among doctors and to illustrate articles on successful amputation procedures. KW

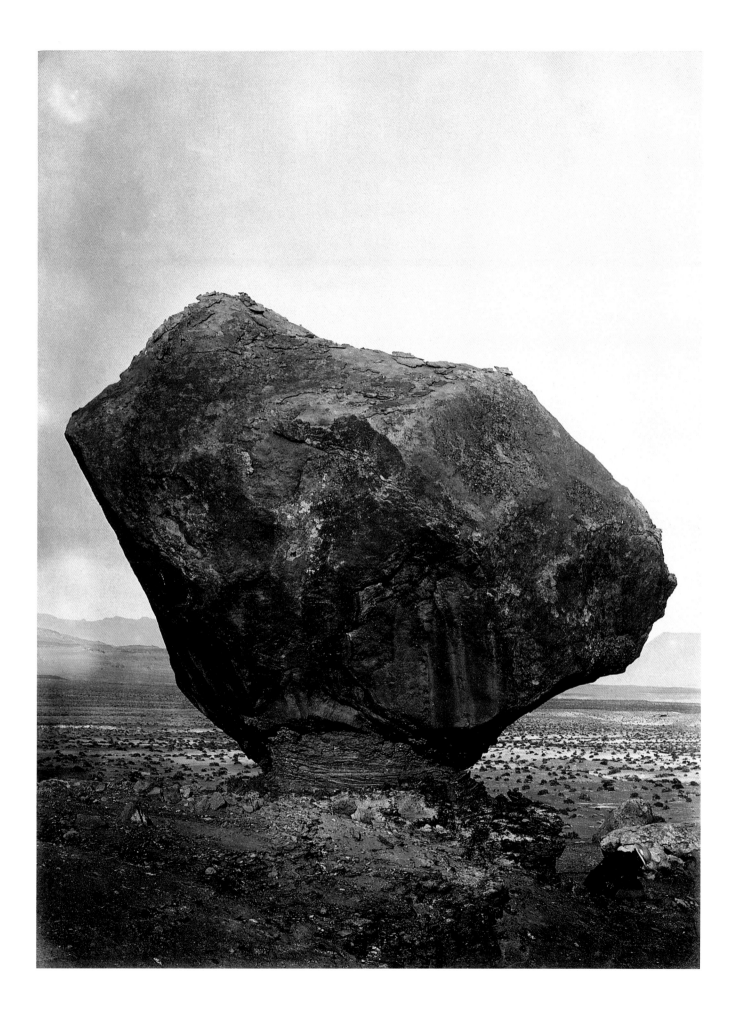

21 ALEXANDER GARDNER
American (born Scotland),
1821–1882
*Lincoln on the Battlefield
of Antietam, Maryland,*
October 3, 1862

Albumen print
22 x 19.6 cm (8⅝ x 7¾ in.)
84.XM.482.1

After emigrating from Scotland to the United States in the spring of 1856, Alexander Gardner, already an experienced photographer, was soon hired by portraitist Mathew Brady to work in his studio. Five years later, when the Civil War erupted and the sound of cannons firing could be heard from the steps of the U.S. Capitol, Gardner reportedly gave Brady the idea of assembling a team of photographers to capture—as best they could with the slow and inflexible photographic equipment at their disposal—images of the war. Gardner made hundreds of photographs himself in the field in 1862 and 1863. His images of the corpse-strewn battlefield at Antietam, Maryland, created a sensation when they were displayed at Brady's New York gallery in November 1862; nothing so graphic and brutal had ever been seen in American photography.

Gardner's most enduring legacy are the thirty-seven surviving portraits he made of Abraham Lincoln, in which the president is shown either alone or with family, friends, and professional associates. Gardner was sufficiently acquainted with the president to be granted a temporary studio at the White House during 1861 and 1862. On October 3, 1862, two weeks after Union general George B. McClellan's defeat of Confederate general Robert E. Lee at Antietam, Lincoln visited the battlefield and conferred with some of his top staff, including McClellan, Major General John McClernand, and Alan Pinkerton, head of the Secret Service. Pinkerton had hired Gardner to work on a top-secret special project to duplicate the hand-drawn maps used to plan campaigns. Lincoln's real purpose for the visit, however, was revealed in a telegram to his wife in which he said he was going to Antietam "to be photographed tomorrow a.m. by Mr. Gardner if we can be still long enough."

Five different poses have survived from the Antietam photograph session, including the one reproduced here. No ordinary portrait, it could only have been made by someone very familiar with the subjects. Lincoln himself failed to stand completely still, as he had predicted, and as a result his head appears slightly blurred. The genius of this picture lies in Gardner's skillful composition built around the visual details of camp life. The tent and tent lines dominate. The eye is thus drawn as much to the fastening on the lines as it is to the faces of the principals. Despite the compositional interruptions, the imposing figure of Lincoln remains the center of interest. WN

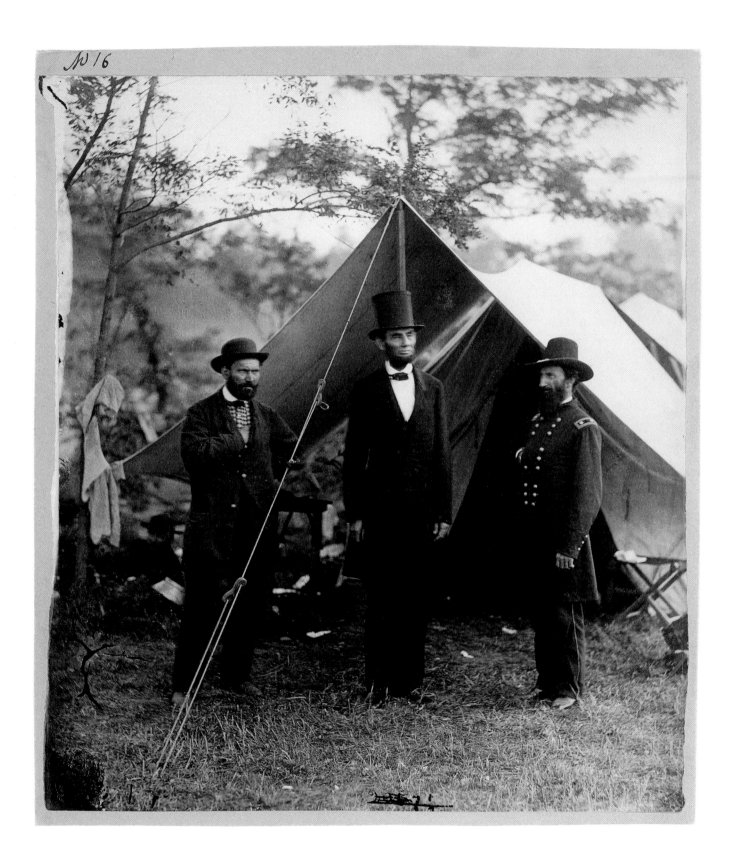

22 GEORGE N. BARNARD
American, 1819–1902
Nashville from the Capitol,
negative 1864; print 1865

Albumen print
25.6 x 35.9 cm (10 1/16 x 14 1/8 in.)
84.XM.468.3

Detail overleaf

The American Civil War gave many photographers new subjects for their cameras. After a prewar career as a portrait photographer in upstate New York, George N. Barnard was for a time employed by Mathew Brady and occasionally collaborated with James Gibson in photographing fortifications around Washington and battle sites in Virginia. In 1863, he became an official Union Army photographer, working in the western theater of the war, the states along the Mississippi River.

This striking view of the capital of Tennessee from the steps of its newly completed capitol building is one of the first in a long series of images Barnard made as he followed in the steps of General William Tecumseh Sherman's brutal 1864–65 campaign, from its start in Tennessee, down into and across Georgia to Savannah and the sea, and then north into the Carolinas. After the war Barnard published a selection of them in *Photographic Views of Sherman's Campaign*, a handsome volume of sixty-one mounted albumen prints (from which this photograph comes). Barnard made three views at this site. This view, of Union soldiers in the portico of the building and a row of Union cannons pointing out over a defensive wooden palisade and earthen embankment at the city beyond, was intended to dramatize Sherman and his army's mastery of the once-rebellious city. He establishes this dominance through his positioning of the camera on a portion of the parapet of the building so that the colonnade and its base create an emphatic vertical thrust that defines the whole of the pictorial space. The cannons become a series of silent sentries, modern peacekeepers. Their powerful masculinity of form, material, and purpose contrasts with the femininity of the graceful, decorative classical statues at the base of the lanterns. In the foreground is a trace of a ghostly human guard who moved out of the picture frame during the long exposure. In the far distance, barely discernible along the line of the Cumberland River, are large numbers of Union tents, evidence of the enormous buildup of men and material preparatory to the launch of Sherman's great venture. When the picture was published in 1866 Barnard added the dramatic sky from a second negative. After the war, Barnard settled for a time in Charleston, one of the southern cities whose destruction he had so memorably chronicled. His later career as a portrait photographer played out in Chicago, Rochester, New York, and Painesville, Ohio. GB

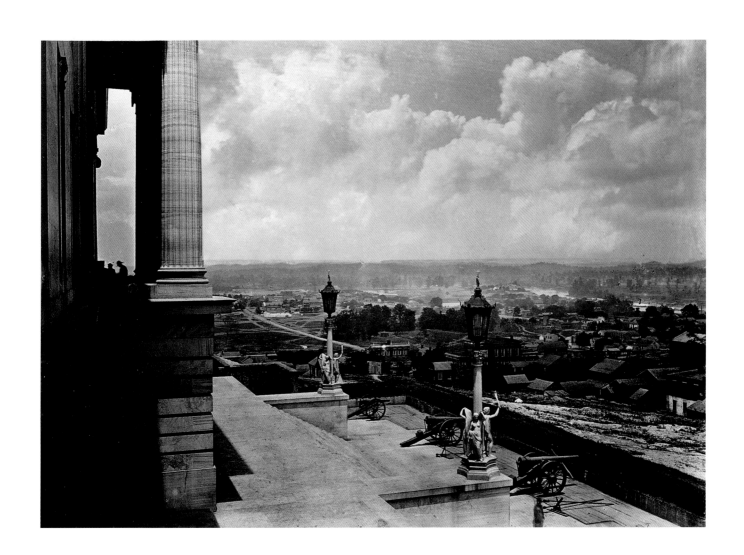

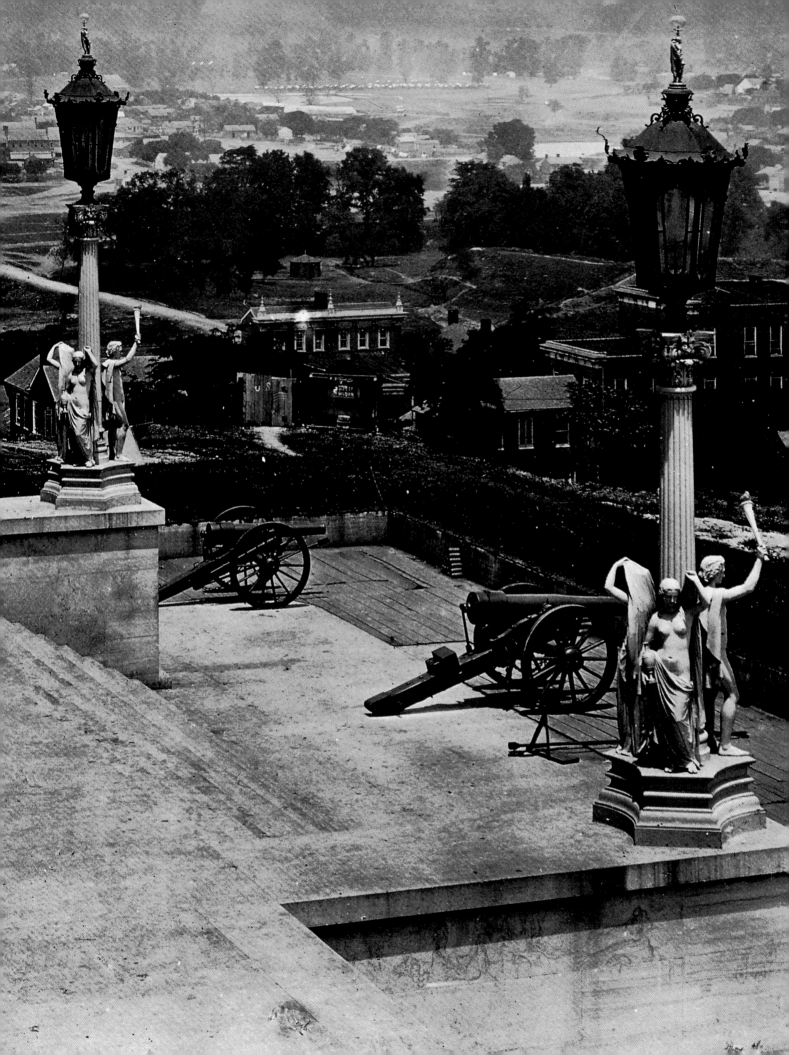

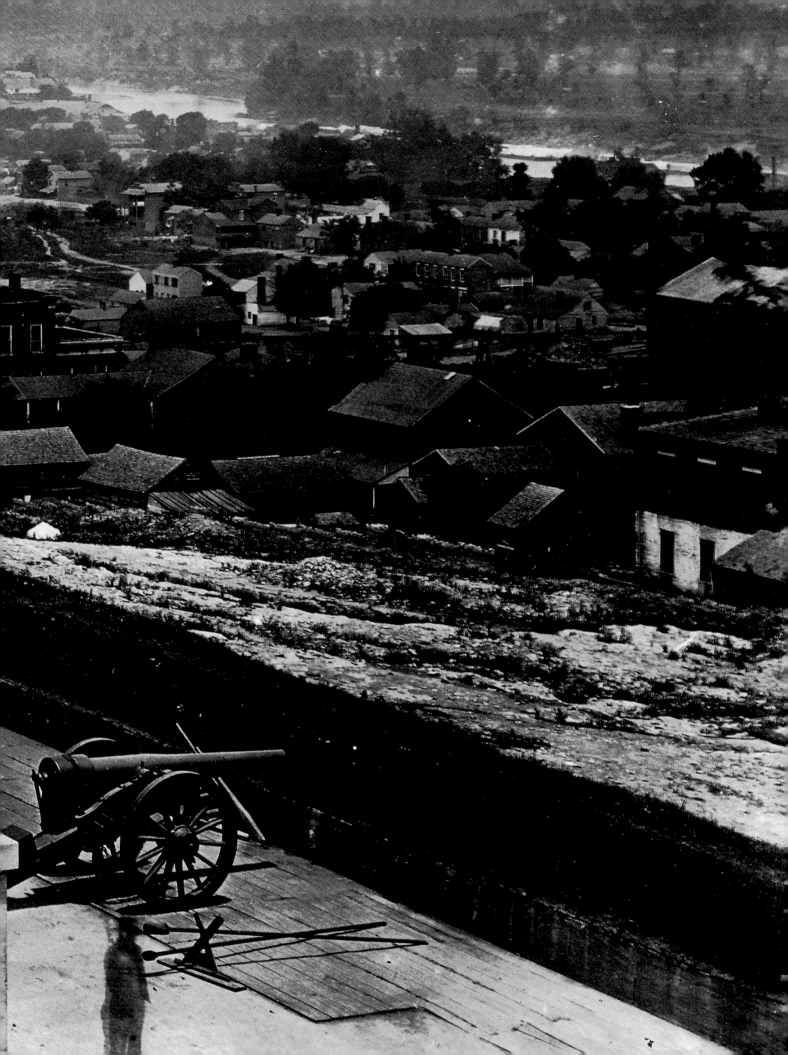

23 CARLETON WATKINS
American, 1829–1916
Multnomah Falls,
Columbia River, Oregon, No. 422,
2500 feet, 1867

Albumen print
52.4 x 39.9 cm (20⁹⁄₁₆ x 15¾ in.)
85.XM.11.28

Arriving in California from New York in the early 1850s, Carleton Watkins began his career in photography somewhat by chance, when he found himself filling in for an absent employee at Robert Vance's daguerreotype studio in Marysville. Within ten years, Watkins was running his own portrait studio in San Francisco. After a financial setback in 1875, he lost his entire inventory of photographs to a competitor, Isaiah Taber. Undeterred, Watkins set about replacing his stock and continued to produce an extensive body of work, traveling up and down the Pacific coast as far north as Canada and as far south as Mexico.

In depicting the relationship between nature and humankind, Watkins's photographs have influenced our interpretation of the landscape. Keen to promote the beauty of the land, he often presents the West as an Edenic paradise, magnificent and awe-inspiring in its natural state. Commissioned by the Oregon Steam Navigation Company in 1867, Watkins journeyed through Oregon, where he made at least fifty-nine mammoth negatives (one of which was used to make this print) and more than one hundred stereographs.

In this photograph of the Multnomah Falls, Watkins highlights the sublime qualities of the natural setting. With no visible sky and the lack of a foreground, the frame is filled entirely by the waterfall and the surrounding foliage. The large size of the print serves to increase the monumentality of the scene. The image is dynamic, not only in its grand scale, but also in its apparent lack of horizontal progression from the foreground to the background. By denying the viewer a sense of spatial recession, Watkins causes the image to hang peculiarly in mid-air. Operating on a vertical arrangement, the waterfall is the key element holding the picture together. As it descends from the top of the image to the bottom, Multnomah Falls is presented as a great natural force that evokes feelings of awe, fear—and even sensuality. Through his choice of viewpoint and his omission of human presence, Watkins depicts nature as a pure and unspoiled phenomenon. AL

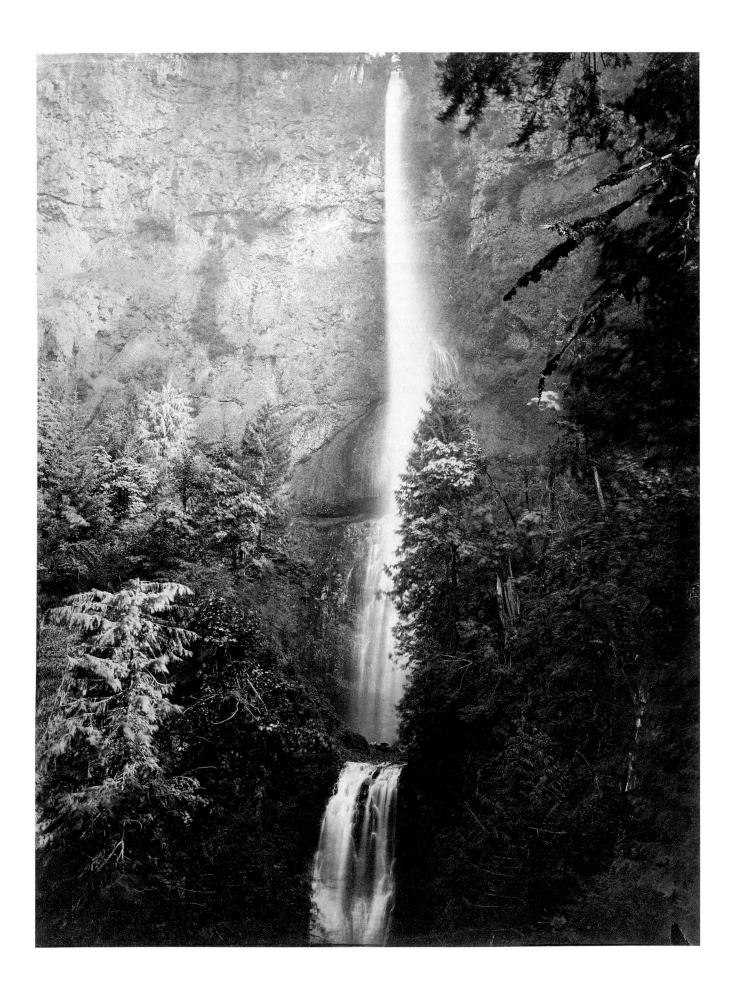

24 HENRY HAMILTON
BENNETT
American (born Canada),
1843–1908
*The Photographer with
His Family: Ashley, Harriet,
and Nellie,* 1888

Albumen print
44.4 x 54 cm (17½ x 21¼ in.)
84.XP.772.8

Detail overleaf

In 1865, after returning from service in the Civil War (where he suffered a crippled right hand), Henry Hamilton Bennett purchased a photography studio in his hometown of Kilbourne, Wisconsin, in partnership with his brother George. The advent of the railroad brought tourists intent on savoring the landscape of the Wisconsin River, a tributary of the upper Mississippi River. The Wisconsin winds through picturesque ravines cut through the soft stone walls of the channel by the flowing water, an area called "the Dells" by the locals. The brothers divided the studio's business into its logical components—landscape and portraiture—and worked together in this way for several years, until George quit the business and moved to Vermont.

By the early 1870s, Henry Bennett had fallen in love with nature and began to devote himself chiefly to landscape photography. He wrote in his journal in 1866: "Went to the Dells; water the highest it's been for a great many years. It's terrible, awful, sublime, majestic and grand." For the next twenty years, Bennett spent most of his creative energy interpreting the landscape near his home. The Wisconsin Dells became a magnet for visitors who were lured to the region by the photographs and guidebooks Bennett produced.

Bennett often incorporated his family and friends into his pictures, posed in a steam launch or resting on the shore; thus, his landscape work has the feel of a family album. Bennett's sense of portraiture was evidently informed by his experience with landscape. In this self-portrait with his son Ashley and daughters Harriet and Nellie, distance separates the figures like fixtures in a landscape. This photograph may have been made to record the family's mourning of Bennett's wife Frances, who died in 1884. The large room is furnished with works of art, suggesting prosperity. However, our attention is caught by the staging of the scene, which seems somewhat unnatural. Above Bennett's head hangs a landscape painting by an unidentified artist; at far right, Nellie holds a photograph album in her lap, while behind her is a Civil War sculpture on a pedestal; to the left of Ashley is an oil painting displayed on an easel that has been cropped in half by the camera. Only Harriet looks directly at the camera; the other three stare into the distance to the camera's left. Could they be gazing at a portrait of Frances, the lost wife and mother? WN

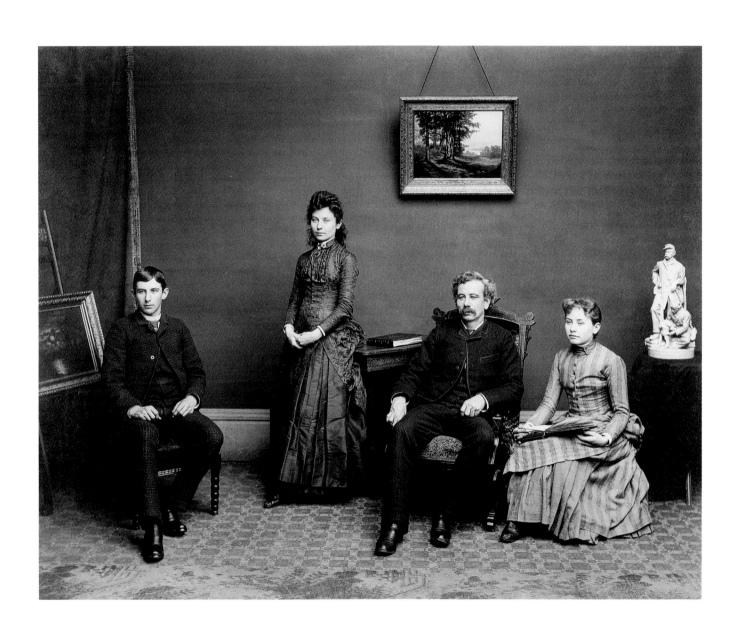

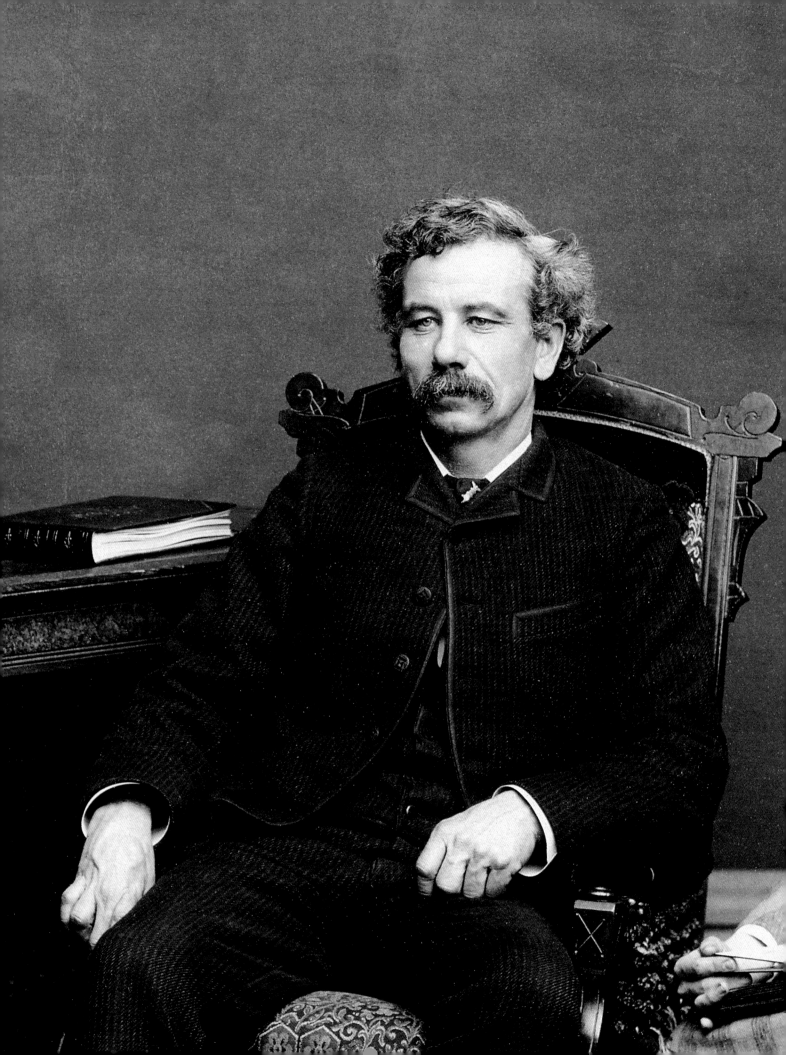

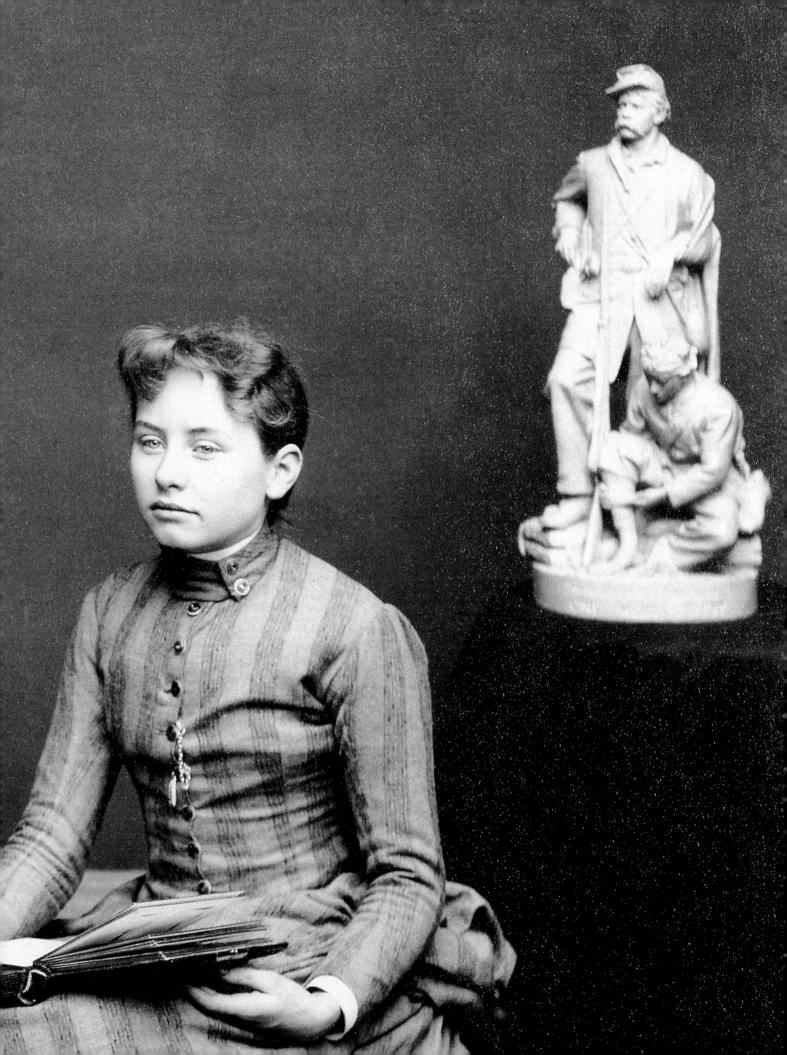

25 FREDERICK H. EVANS
English, 1853–1943
*Across West End of Nave,
Wells Cathedral,*
circa 1900

Platinum print
15 x 10.5 cm (5⅞ x 4⅛ in.)
84.XM.444.38

From a youthful position as bank clerk, Frederick H. Evans graduated to bookshop proprietor in the 1880s and struck up acquaintanceships with members of London's creative community. At about the time he was changing professions, he began to indulge in an avocation that would become his third career. He started by photographing shell and insect forms through a microscope and then mounting the results on glass slides. This exercise, along with his admiration for the designs of William Morris and the drawings of Aubrey Beardsley, fostered a desire to produce his own photographic prints. His most frequent motifs, landscape and architecture, are reflected in the imitation of natural forms and the accent on extreme artifice seen in this narrow view of a monumental medieval structure, the cathedral at Wells. The image miraculously brings the church's tall, rib-vaulted interior down to human scale while still respecting its delicate Gothic details. The soft, even light—for which he probably waited hours, if not days—imbues the multiple colonnettes of the massive nave piers with an ethereal quality that continues into the arcade of the triforium above. Evans's unexcelled mastery of the platinum printing process allowed him to create subtle accents in his print, such as the near-black slice of shadow in an upper clerestory passage at the top edge of the composition and the off-white radiance issuing from the main entrance at the lower right.

Like the contemporary writers Victor Hugo and J. K. Huysmans, who both took the cathedral as a principal theme, the literate Evans was fascinated by the art and architecture of the Middle Ages. He visited many of the best of these monuments, such as the cathedrals at Lincoln, Rheims, Durham, Bourges, Ely, and Wells, with view camera and glass negatives. Built of local limestone in two campaigns between 1185 and 1350, Wells Cathedral still overshadows the small ancient city in which it was raised. It underwent some later restoration, but the nave, sometimes described as the long limb of the church, has been preserved intact. The nave arcade, when seen in its entire length, has an earthbound horizontality, which Evans fractures to emphasize the verticality of its individual elements. The sharply incised lines read more like a drawing than a stone monument. A dedicated worker in his own way, Evans derived his luminous vision from the faith and skill of the anonymous craftsmen who created this great church. JK

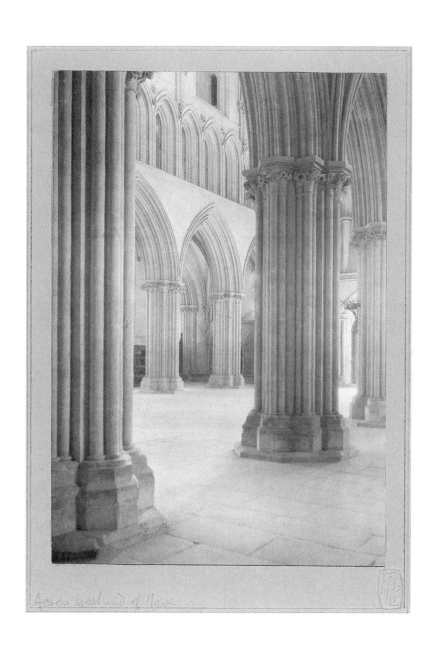

Across west end of Nave

26 GERTRUDE KÄSEBIER
American, 1852–1934
Silhouette of a Woman,
circa 1900

Platinum print
20 x 10 cm (7⅞ x 3¹⁵⁄₁₆ in.)
87.XM.59.28

The independence of a pioneer upbringing combined with a Pictorialist aesthetic allowed Gertrude Käsebier to achieve tremendous artistic and professional success as a portrait photographer. She grew up in Colorado and, in adolescence, moved to Brooklyn, New York, where she ultimately married and raised a family. In the late 1880s, Käsebier began studies in formal art training at the Pratt Institute in Brooklyn. Initially working in the traditional disciplines of painting and drawing, she soon discovered photography and, over the objections of her family, began an apprenticeship in a commercial portrait studio. Käsebier then opened her own studio. Working without the Victorian furniture and props preferred by most photographers of the day, she developed a new style of soft focus and artistic lighting. Käsebier became a member of the New York Camera Club and the Linked Ring (based in London). She was also a confidante of Alfred Stieglitz and Edward Steichen, who were cofounders of the Photo-Secession, an informal association of photographers dedicated to securing photography's place among the fine arts.

This photograph, possibly taken on the occasion of her daughter's wedding, is reminiscent of a quattrocento Madonna, with the subject seen in profile, hands folded in prayer, wearing a translucent veil. Käsebier emphasized the role of women and motherhood in her work, charging this image with a suggestion of virginal purity (its alternate title is *A Maiden at Prayer*) and equating matrimony with a heightened sense of spirituality. This sentiment becomes more poignant with the knowledge of Käsebier's own troubled marriage. Not a true likeness, the image makes use of a near-sculptural modulation of light and dark tonal values, as the silhouette is softened by the focus on the background door frame and exterior view. The Pictorialist sensibility so evident in Käsebier's work led Alfred Stieglitz in 1898 to call her "the leading portrait photographer in the country." JM

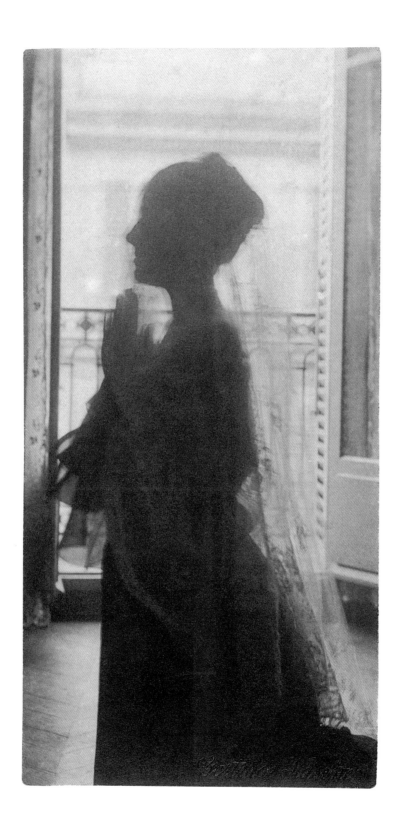

27 ANNE BRIGMAN
American, 1869–1950
The Heart of the Storm,
circa 1910

Platinum print
24.6 x 19.7 cm (9¹¹/₁₆ x 7¾ in.)
94.XM.111
Gift of Jane and Michael Wilson

Anne Brigman taught herself photography around 1901 and by the following year was exhibiting her work at the San Francisco Photographic Salon. Not long afterward, she began corresponding with Alfred Stieglitz in New York (see no. 30) and became an early member of his Photo-Secession group. Stieglitz became a champion and collector of Brigman's work; he also published her photographs in his richly printed journal *Camera Work.* Brigman's images are in the Pictorialist style, characterized by a soft-focus, picturesque approach to subject matter. Brigman produced her photographs by enhancing what she had recorded on film with hand work on the negative or print.

Brigman was as passionate about the transformative power of nature as she was about the artistic possibilities of photography. At a time when most nude photographs were taken by men in studio settings, she was a pioneer in capturing the female nude in the wilderness. In her writing and her photographs, she describes in ecstatic terms the experience of being in the western landscape, and her pictures often suggest a sacred union between man and nature.

The Heart of the Storm embodies this connection, expressing the cataclysmic forces of nature while also establishing a place for mankind within them. Threatened by the power of the oncoming storm, the figures find refuge in the shelter of the trees. The lines on the draped figure's gown echo the striated tree trunk behind it. The nude figure with a halo, added to the negative by Brigman, may represent a guardian angel or a dryad, beckoning the other figure to safety. Because the symbolism and mysticism of Brigman's photographs are intensely personal, the specifics of the narrative may be unclear; nonetheless, the image grips us with great emotional power. KW

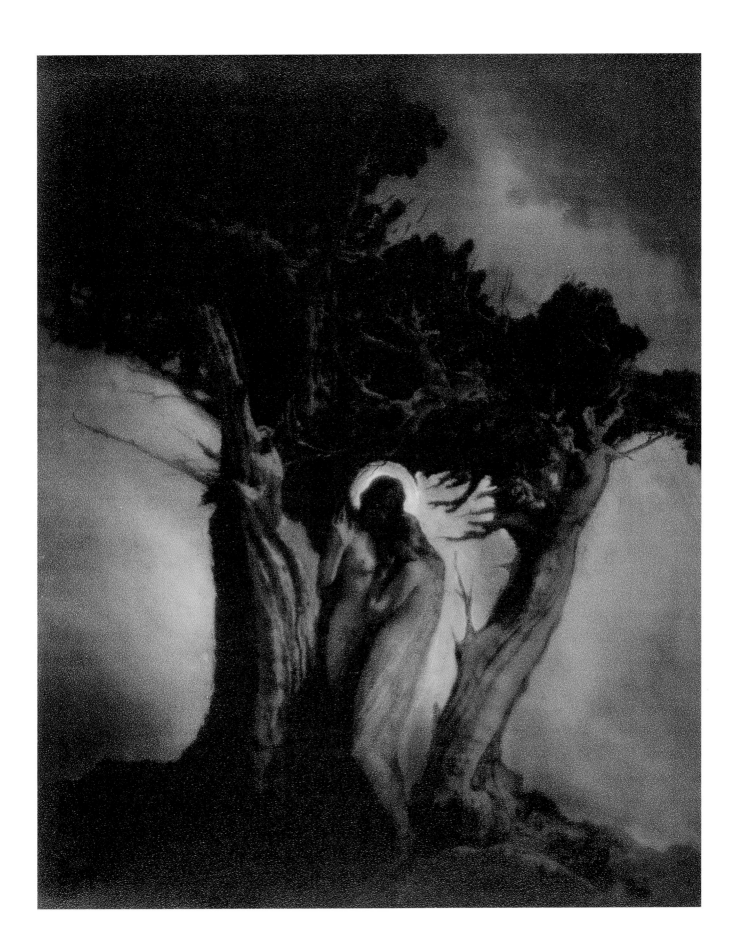

Lewis W. Hine was born in Oshkosh, Wisconsin, where he attended the State Normal School and came under the influence of Professor Frank A. Manny, a specialist in education and psychology. In 1900, he enrolled at the University of Chicago, where he was influenced by the educational theories of John Dewey and Ella Flagg Young. In 1901 Hine was hired by Professor Manny, his Oshkosh mentor, to teach nature study and geography at the Ethical Culture School in New York City. He subsequently earned a Master's degree in Education and enrolled in the Sociology Department of Columbia University for more graduate work, one of the few photographers of his generation to achieve this level of higher education.

By the time he reached thirty, Hine had studied education and psychology with some of the best people in the field, but he had not yet discovered the usefulness of photography to his vocation in teaching and social work. Apparently Manny urged Hine to take up photography at the age of thirty-three and involved him in a project to record immigrants at Ellis Island. Hine used a tripod-mounted camera to photograph his subjects and magnesium flash powder to light them. By 1907 he had decided to devote himself exclusively to photography and, at the invitation of Paul Kellogg, joined the team of social workers, artists, and journalists documenting social conditions in the city of Pittsburgh. Based on his success with human-interest photography, he was hired to work for the National Child Labor Committee in New York in 1908 at a salary of $100 per month plus expenses.

Hine made *Self-Portrait with Newsboy* shortly after he went to work full time for the National Child Labor Committee. He spent eight years there documenting the exploitation of children under the age of fourteen in the workplace. He coined the phrase "photostory" to describe the process of creating a narrative on facets of his subject destined for the printed page. His genius lay in powerfully interweaving objectivity with the strong personal feelings he had for the faces before his camera. Dominating the foreground here is his own shadow holding the shutter-release cable attached to the tripod-mounted camera. The time is probably early morning; the boy wears a hat advertising Coca-Cola; in the background is an advertisement for the Danbury Hat Company. Hine favored bright light to amplify every detail of the picture; however, this forces the boy, whose arm is barely longer than a newspaper page, to cock his head as he looks into it. WN

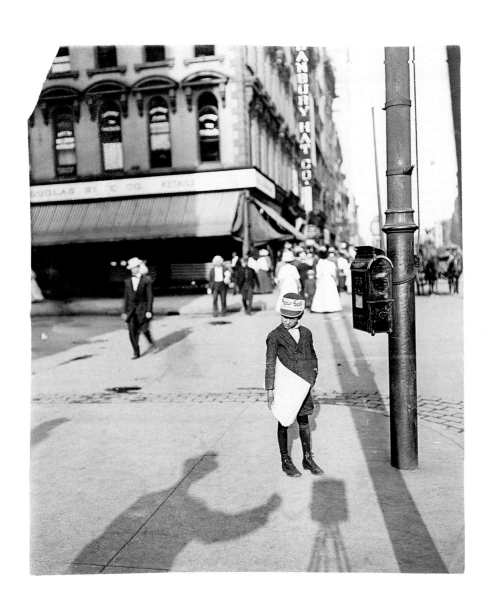

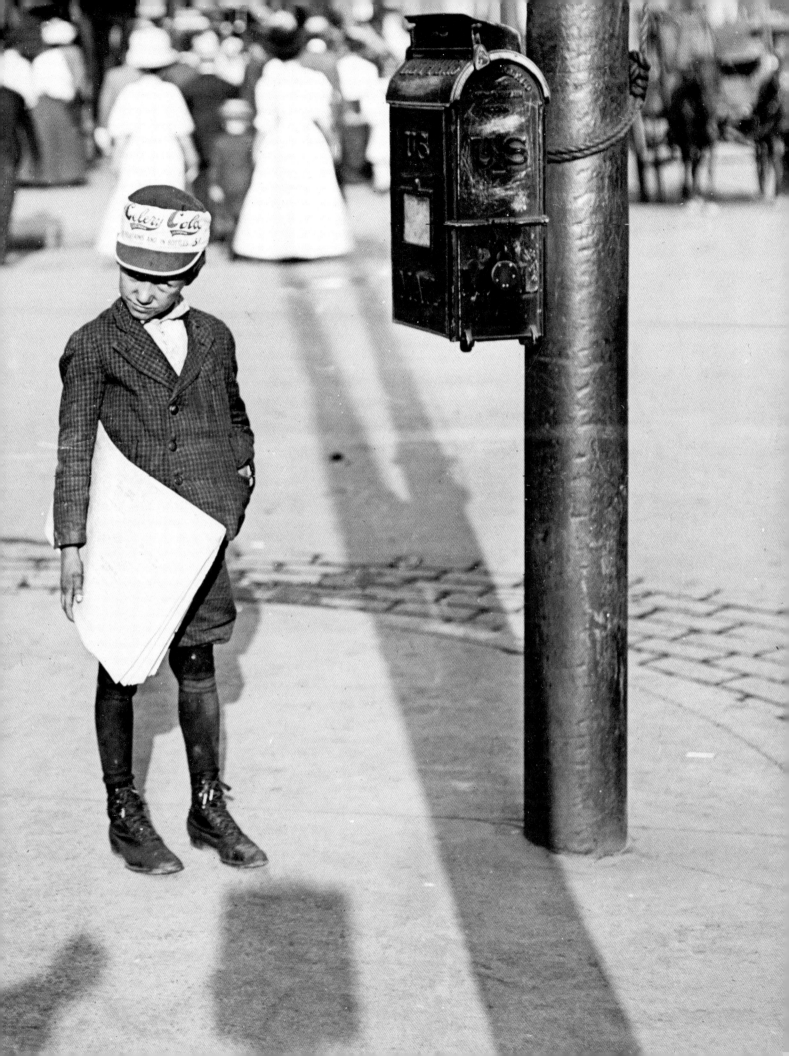

29 BARON ADOLF
DE MEYER
American (born Germany),
1868–1946
Portrait of Josephine Baker,
1925

Gelatin silver print
39.1 x 39.7 cm (15⅜ x 15⅝ in.)
84.XP.452.5

Destined to become the first renowned fashion photographer, Baron Adolf de Meyer spent his life navigating in and out of social circles in Europe and the United States. At the height of his career, he was a self-made authority on taste and an arbiter of manners. For years De Meyer practiced photography as a highly talented amateur and as a member of both the Linked Ring and the Photo-Secession (see no. 26); the Pictorialist sensibility he developed directly influenced his later commercial work. De Meyer fled Europe for New York before the outbreak of World War I and became a full-time professional photographer there. At that time, the various fashion magazines relied on engravings and drawings for most of their fashion illustrations. De Meyer, along with Edward Steichen, heralded a new era with their artistic interpretation of fashion costume and accessories through the lens of the camera. One working for Condé Nast and the other for William Randolph Hearst, they almost simultaneously created the profession of fashion photographer as we know it today. De Meyer worked solely for publications of the highest quality, including *Vogue, Vanity Fair,* and *Harper's Bazaar,* wherein he produced "society portraits" and elegant advertisements. His photography is characterized by soft, diffused light, casual sophistication, and a glamorous elegance, and he invented a type of backlighting that turned women's hair into haloes bathed in an aura of light.

The Baron was especially adept at capturing the personality of his sitters; he could bring out the dual qualities of intelligence and sexuality in his female subjects. De Meyer's image of Josephine Baker is an outstanding example of this skill; the photograph was taken as an advertisement for the Folies-Bergère sometime after her Paris debut. A dancer from St. Louis, Missouri, Baker caused a sensation in France with her exotic sexuality, effervescence, allure, and comic abilities. De Meyer captures Baker's identity through her face rather than her celebrated body. Her off-center pose, as though she is about to begin a dance, is balanced by the softly focused background and the calculated lighting effects which highlight her large, mischievous eyes. JM

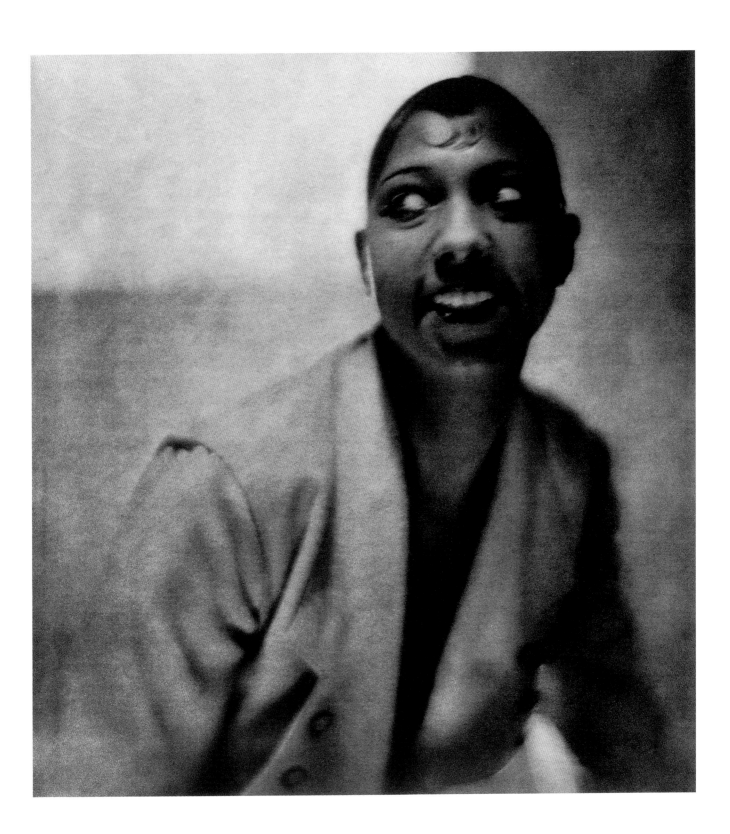

30 ALFRED STIEGLITZ
American, 1864–1946
Georgia O'Keeffe: A Portrait,
1918

Palladium print
24.3 x 19.3 cm (9⁹⁄₁₆ x 7⅝ in.)
93.XM.25.53

Few names in photography are as well known as that of Alfred Stieglitz. In the first decade of the twentieth century, he proved to Americans, through his photographs, writing, and the publications he edited, that photographs could indeed be works of art. When Stieglitz met the artist Georgia O'Keeffe in 1916, he had been an exhibiting photographer for a quarter century. In the twenty years of creative time ahead of Stieglitz, O'Keeffe became his muse, his wife, and his best friend.

During the first half of 1916, when O'Keeffe was living and painting in New York, Stieglitz included her watercolors in a group exhibition at his gallery, 291. O'Keeffe visited the gallery and reportedly demanded that he take down her works because he had not asked permission to display them. Thus began their tumultuous thirty-year relationship. Two years later they fell deeply in love and began to live together in a fifth-floor studio on Madison Avenue owned by Stieglitz's niece.

The summer of 1918 in New York was one of the hottest in memory. "It was so hot that I usually sat around painting with nothing on," recalled O'Keeffe, whose various states of undress were seized upon by Stieglitz as an opportunity to photograph her in a great variety of moods and from many different perspectives. For comfort, O'Keeffe often wore a diaphanous white kimono with an embroidered floral pattern. In this portrait, her uncoiffed hair flows over her shoulders in a composition that effectively crosses back and forth between the real and the ideal, the declared and the symbolic, the evident and the hidden. O'Keeffe gazes directly at the photographer, thus involving the viewer in the experience. Her pose and gesture recall not only Madonna figures of the *Virgo Lactans* type in Christian iconography but also Buddhist goddesses whose hands cup their breasts. Stieglitz no doubt intended the general association of sexuality as an expression of the sacred.

Over the next two decades, Stieglitz kept approximately 325 of the studies he made of O'Keeffe. He gave the ensemble, which has never been published or exhibited in its entirety, the collective title of *Georgia O'Keeffe: A Portrait*. WN

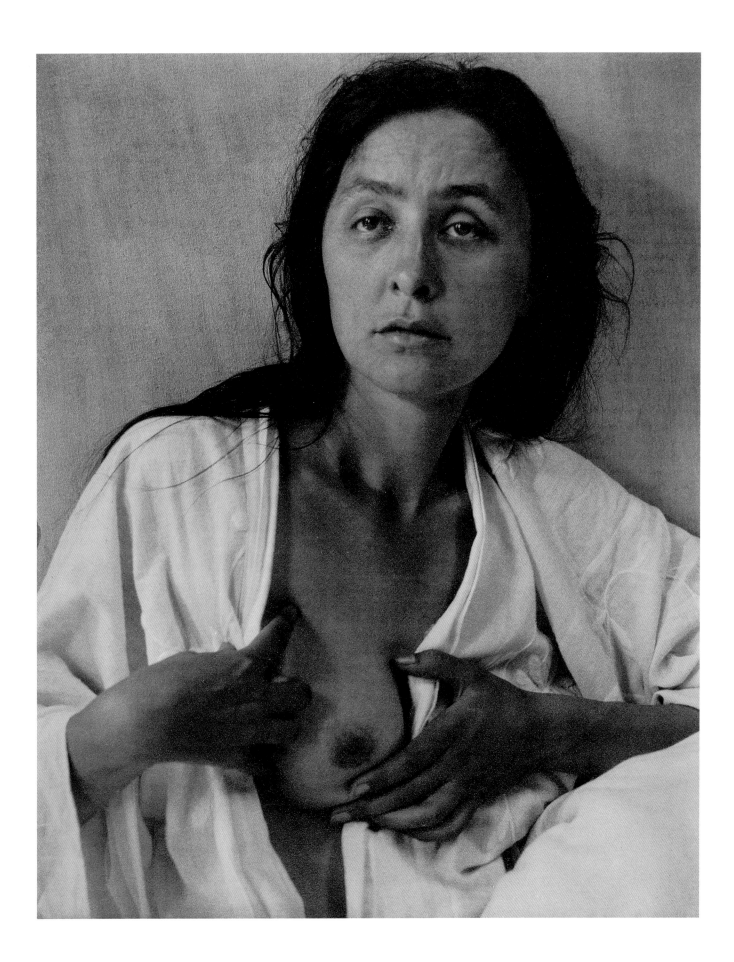

31 PAUL STRAND
American, 1890–1976
Rebecca, New York, 1923

Palladium print
25.2 x 20 cm (9^{15}/$_{16}$ x 7^{7}/$_{8}$ in.)
86.XM.683.54

Paul Strand was born in New York City and learned about photography as a student in an after-school club sponsored by Lewis Hine (see no. 28) at the Ethical Culture School. Hine's compositional style and his interest in photography as an instrument of social change had a strong impact on Strand, although their association was brief. Strand later became the protégé of Alfred Stieglitz, who sponsored his first one-man show in 1916 and published his photographs in the deluxe journal *Camera Work* in 1916 and 1917.

Strand married Rebecca Salisbury in 1922, the year before he made this intimate portrait. He had begun photographing her in 1920, soon after they met, and made more than one hundred pictures of Rebecca during their twelve years together. During the 1920s, the Strands were close friends with Stieglitz and Georgia O'Keeffe, and this group of pictures is indebted to Stieglitz's serial portrait of O'Keeffe (see no. 30). Strand's portraits of his wife, however, are characterized by a raw emotional honesty that is not found in Stieglitz's more structured work.

In this portrait, Rebecca is presented in extreme close-up; she is probably lying in bed. Because of the position of the camera, the viewer hovers over her. The swell and hollow of her bare shoulder are exposed, seemingly close enough to touch. While the camera's scrutiny reveals her physical aspect in nearly microscopic detail, showing every line and freckle of her skin, she denies us access to her thoughts and feelings by closing her eyes and turning her face to the side. Rebecca's pose was partly a function of practicality, since by lying down she was less likely to move and spoil the exposure. The slight blurring of the image conveys a softness that mitigates the harsh, close-up examination of the subject. KW

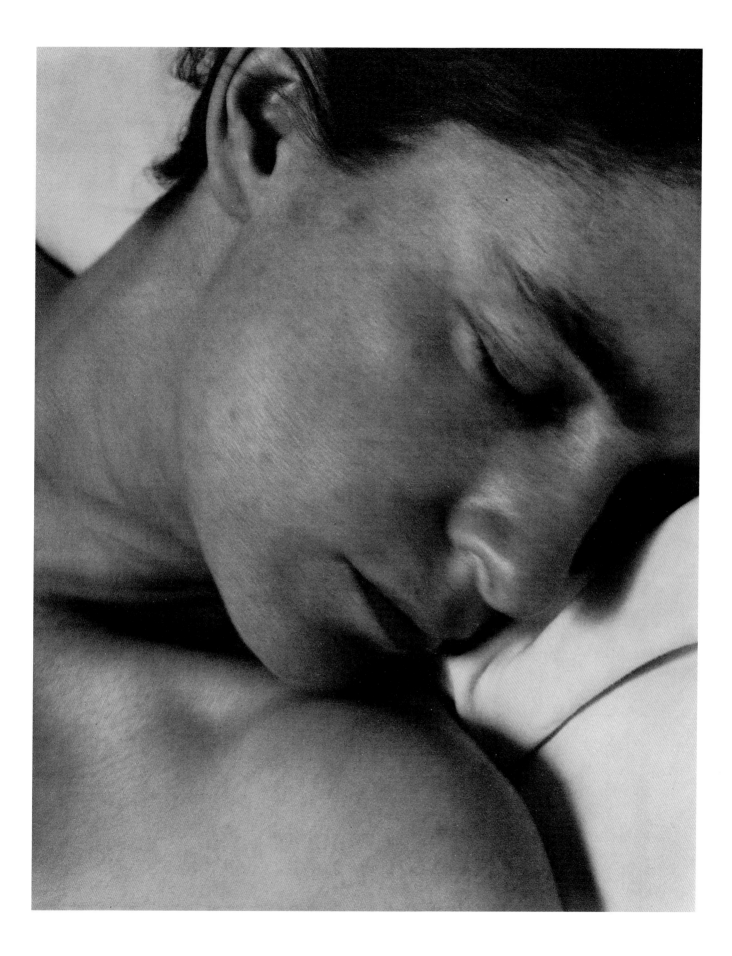

32 EDWARD WESTON
American, 1886–1958
Los Angeles (Plaster Works),
1925

Platinum print
19.2 x 24 cm (7⁹⁄₁₆ x 9⁷⁄₁₆)
86.XM.710.5

Detail overleaf

In his desire to escape the suburban Chicago of his childhood, Edward Weston ran a portrait studio in suburban Los Angeles for more than a decade. Eventually he tired of the routine and the lack of artistic fulfillment. In 1923 Weston departed for Mexico in search of a more authentic culture, a better way to make money, and the freedom to practice his art. He and his companion, the photographer Tina Modotti, were able to see much of the country while completing commissions to document ancient monuments, folk art, and provincial churches. Although he preferred the expatriate bohemian lifestyle, Weston occasionally returned to California to visit his family and exhibit his work. He had photographed the Armco complex in Ohio and would later produce images of Pittsburgh's factories, but industrial architecture would never be a favorite theme for Weston. However, he spent a good part of 1925 back in Los Angeles, and his time there yielded this atypical rendering.

In the mid-1920s, although Weston was trying to break away from the broad painterly style of Pictorialism, he still favored the delicate platinum printing process and could not bring himself to photograph only hard edges. The plaster works pictured here proved to be the perfect subject for this transitional period because its surfaces were continuously replenished with a layer of white powder. Weston's emphasis on the exterior textures of corrugated tin and plaster dust enhances the abstract qualities of this structure of many roofs and chimneys, which, from this vantage point, do not appear to form a solid physical plant. An implication of weightlessness adds to the impression that atmosphere, rather than architecture, is the photographer's main concern. The aura of this print is suffused with the constant sunlight of Southern California. It is, in fact, a singular image of what Weston called "the impossible village." Ironically, the lime and sand that were milled behind these walls would provide an essential material for building up Los Angeles from a "village" to a cosmopolitan city. JK

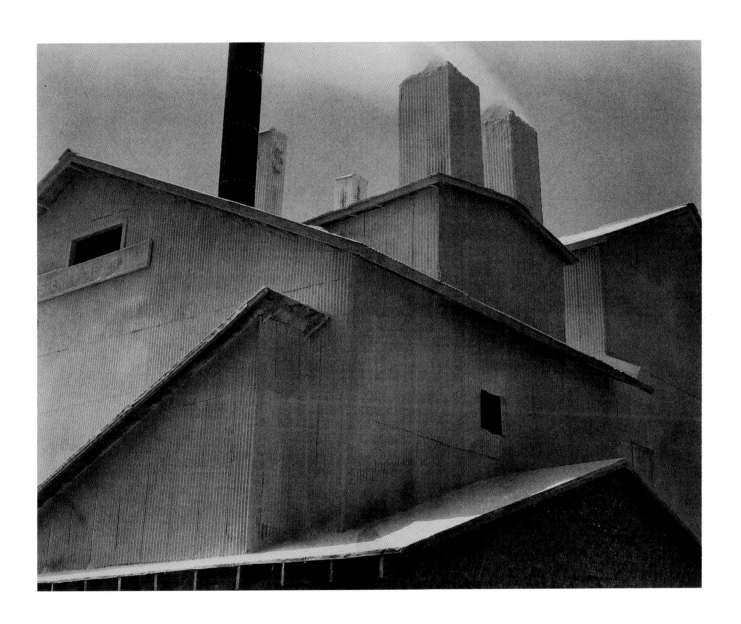

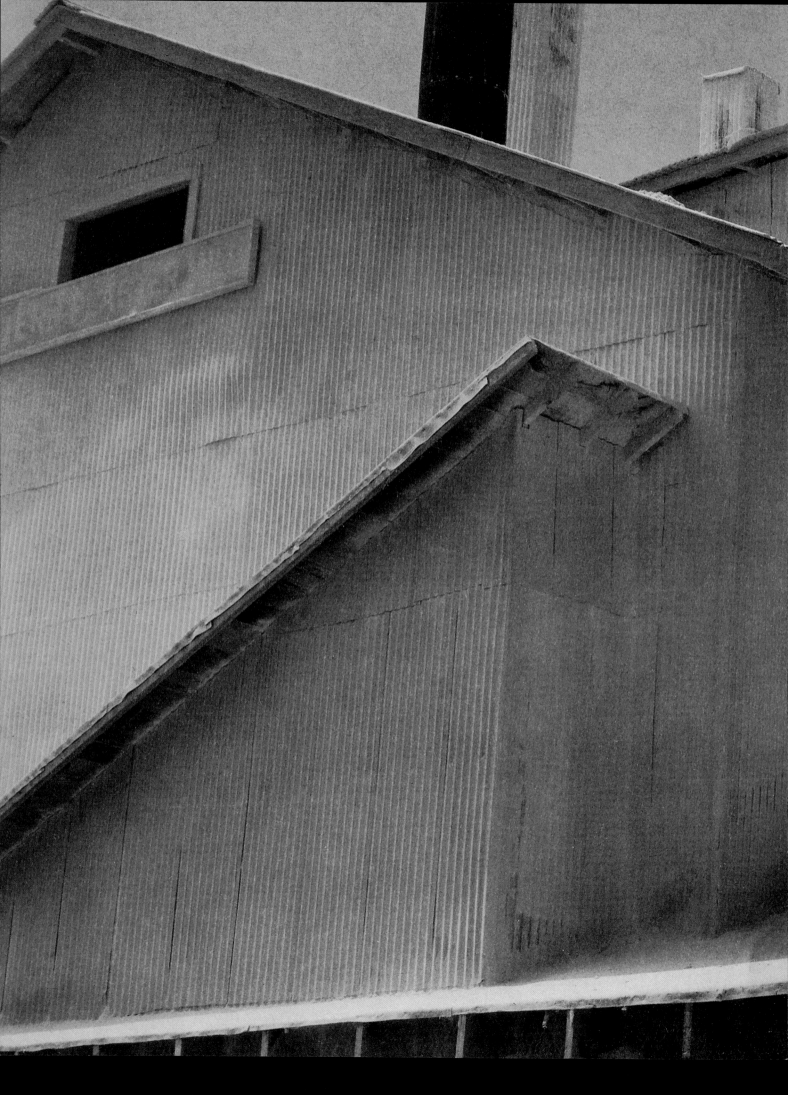

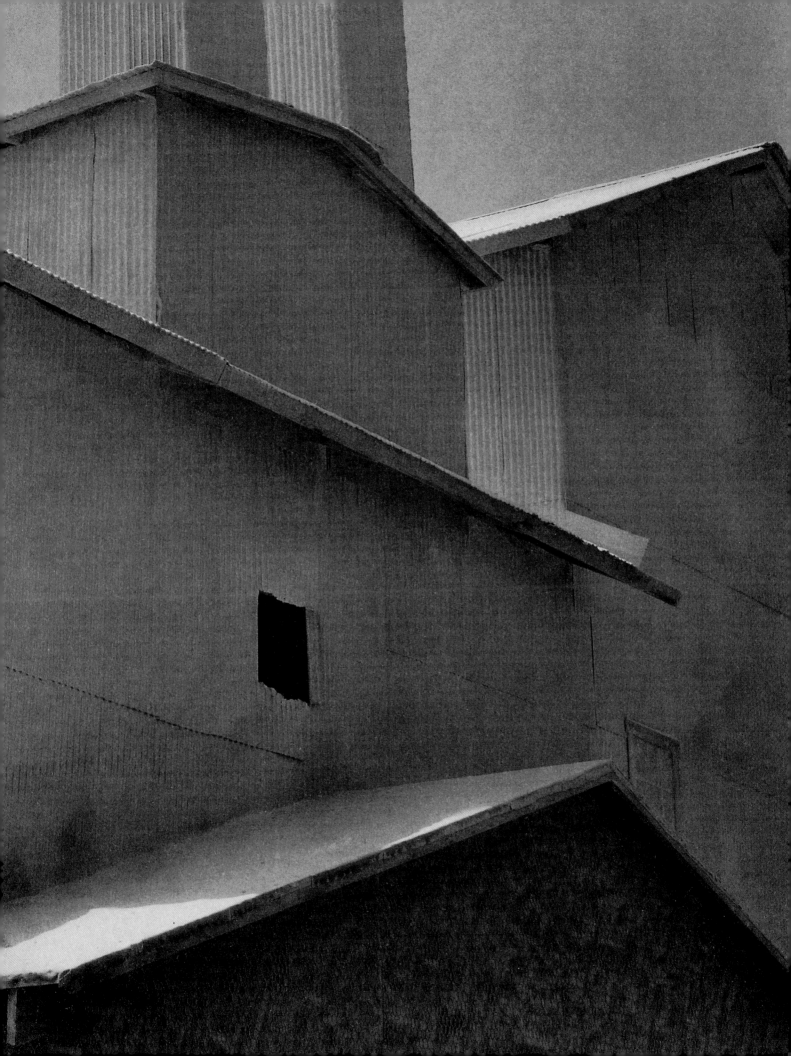

33 EL LISSITZKY
Russian, 1890–1941
Kurt Schwitters, 1924–25

Gelatin silver print
11.1 x 10 cm (4⅜ x 3¹⁵⁄₁₆ in.)
95.XM.39

El Lissitzky was one of the preeminent figures in Russian art of the early twentieth century, best known for his series of non-objective works entitled Prouns. He traveled to Germany in 1909 to study architecture at the Technische Hochschule in Darmstadt, returning to Russia five years later to continue his studies in Moscow. Subsequently, he was invited by the painter Marc Chagall to teach architecture and graphic art at a progressive school in Vitebsk. Lissitzky returned to Germany in 1921, where he became an important disseminator of Soviet artistic developments, helping to organize a large traveling show of Soviet work that was seen in Berlin in the fall of 1922. Early in his stay, he met László Moholy-Nagy (see no. 37) and other members of the international avant-garde in Berlin and became particularly interested in the artistic possibilities of photography. As the utopian Russian painting style of pure shapes and color was giving way to a Communist preference for figurative art, photography perhaps provided a way for Lissitzky to experiment with images rooted in observable reality.

In 1922, Lissitzky met Kurt Schwitters (1897–1948), an artist associated with the Dada movement who was known for his collages and for nonsense sound poems. During a stay in Hanover, Lissitzky collaborated with Schwitters on the July 1924 issue of Schwitters's journal *Merz*, and this dynamic portrait dates from the same period. Although most portraits require the subject to sit still, Lissitzky chose to portray Schwitters in motion, an effect he reinforces by showing multiple views of the artist's head (achieved by using more than one negative to make the final print). Two pictures of Schwitters reciting are superimposed over the cover of *Merz*, a promotional poster, and part of an advertisement. The backdrop offers a compendium of Lissitzky's and Schwitters's activities together and suggests a complexity of personality unattainable in a single view. The parrot that appears in place of Schwitters's mouth probably refers to his squawking recitations of *Ursonate*, a poem of invented words and meaningless sounds. The resemblance of this photograph to a collage also suggests Lissitzky's receptivity to Schwitters's approach to art-making. KW

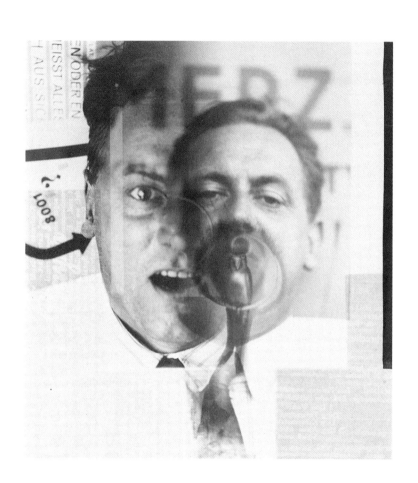

34 MAN RAY
(Emmanuel Radnitsky)
American, 1890–1976
*Untitled Rayograph (Gun
with Alphabet Stencils)*, 1924

Gelatin silver print
29.5 x 23.5 cm (11⅝ x 9¼ in.)
84.XM.1000.171

Born in Philadelphia, Man Ray first traveled to Paris in 1921 and would spend much of his career in that city. The atmosphere of creative freedom there stimulated him to produce some of his most inventive work, including a large body of cameraless photographs that he called "Rayographs." A darkroom mishap while he was developing photographs for fashion designer Paul Poiret reportedly led Man Ray to "discover" the technique (known in the nineteenth century as "photogenic drawing"), which involves placing objects on photographic paper and exposing them to a light source that traces their outlines. "I have freed myself from the sticky medium of paint and am working directly with light itself," Man Ray wrote to his patron Ferdinand Howald in April 1922.

To create this image, the artist arranged a revolver, some stencils, and other items on light-sensitive paper. The letters are scattered like bullets shot from a gun, silhouetted luminously against the inky backdrop. Defying rational interpretation, they refuse to assemble themselves into recognizable words. Man Ray's Rayographs are sympathetic in spirit to Surrealism, a movement that began in France in the mid-1920s, in which writers and artists sought to record their dreams and thoughts uncensored by the rational mind. Similarly, these photographs use objects from the known world to create an ambiguous landscape of the mind. KW

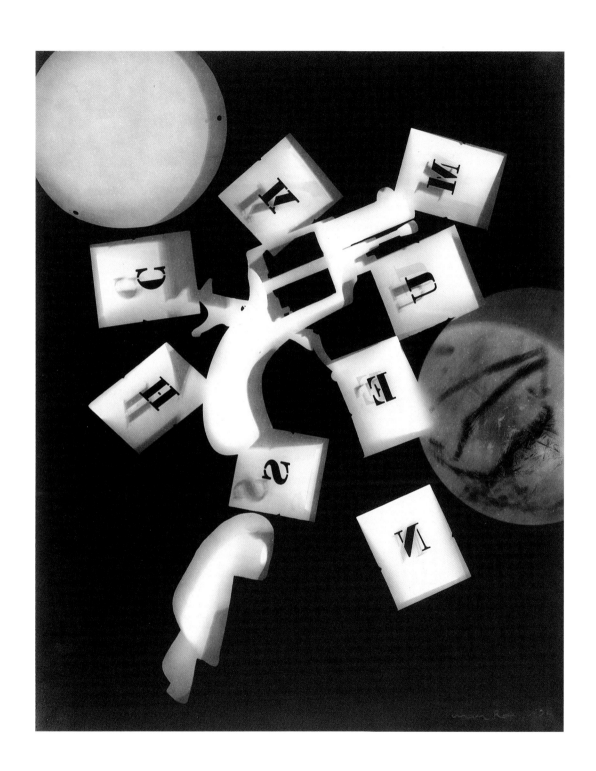

35 EUGÈNE ATGET
French, 1857–1927
Street Fair Attraction, 1925

Gelatin silver print by Berenice Abbott
(American, 1898–1991), circa 1954
17.3 x 22.5 cm (6 13⁄$_{16}$ x 8 7⁄$_{8}$ in.)
90.XM.64.14

Detail overleaf

This anomalous image dates from the end of Eugène Atget's long and productive career as a photographic observer of the city of Paris: its shop fronts, the architectural fragments of its past imbedded in existing buildings, its oldest streets deserted at dawn, and its royal parks. Lit by the bare light bulb that forms the peak of what initially appears to be a stack of unrelated pictures, signs, shoes, and furniture and edged by a sort of window frame, this photograph is at first glance both strange and puzzling. The key to deciphering it lies within the images shown in Atget's photograph. These depict the two performers who regularly used these chairs of such disproportionate sizes—a giant and a midget—with one shoe belonging to each placed next to his respective chair. At the annual street fair of the district of Paris where the negative for this photograph was made, one imagines that the purposely ill-matched pair began their sideshow act by coming forward to sit upon their chairs and put on their missing shoes. This seemingly surreal scene is exactly what drew Marcel Duchamp, Man Ray, and his then studio assistant, Berenice Abbott, to the work of Atget. While they were interested in the bizarre and the unexpected component of his images, Atget's own focus was in recording the merry-go-rounds and circus posters, the puppet shows and menageries that characterized these street fairs, which even in Atget's day were disappearing as urban phenomena. Abbott would prove to have more than a passing interest in Atget's work. She progressed from making a group of portraits of the elderly photographer, to safeguarding his prints and negatives after his death, to establishing his place in the photographic pantheon by writing about his work and reprinting his negatives. GB

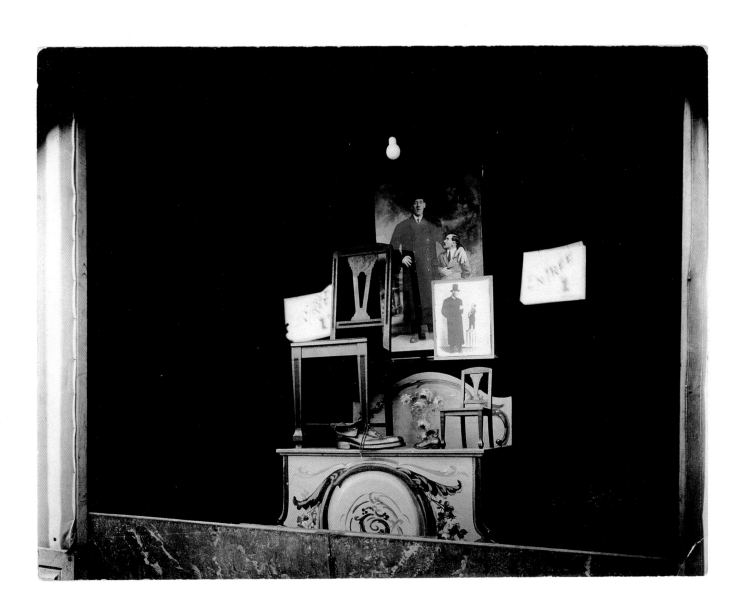

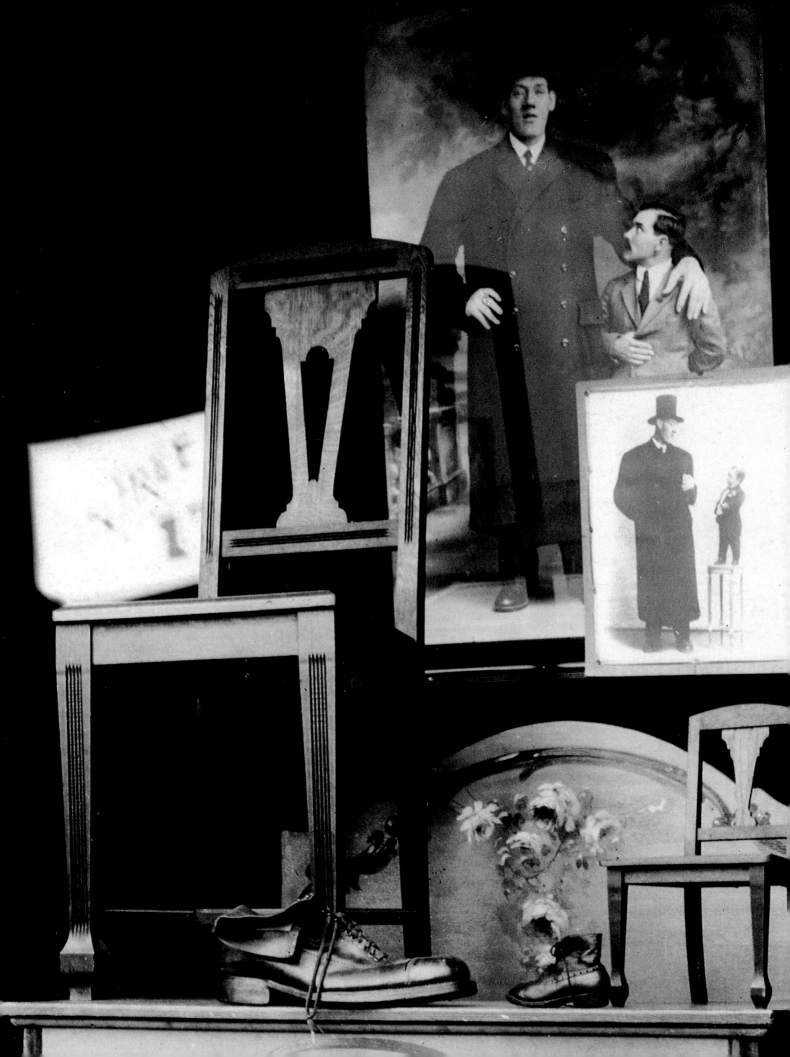

36 ALBERT RENGER-
PATZSCH
German, 1897–1966
Flatirons for Shoe Manufacture,
circa 1928

Gelatin silver print
23 x 17 cm (9 1/16 x 6 11/16 in.)
84.XM.138.1

Albert Renger-Patzsch was twenty years younger than his more famous compatriot August Sander (see no. 38), and the notable differences in their styles may in part be generational. Sander's art came out of the Pictorialist style, but Renger-Patzsch created his approach in reaction to Pictorialism; Sander was a devoted humanist, while Renger-Patzsch was a product of the machine age; Sander admired hand-made art, while Renger-Patzsch was drawn to machine-made products and the whole apparatus of the industrial era.

The sources of Renger-Patzsch's approach to photography are contradictory. As head of the photo studio at the Folkwang (later Auriga) Publishing House in Hagen, Germany, he photographed botanical specimens, often so close up that they become abstractions. He was evidently fascinated by the process of using a machine—his camera—to express the poetry of purely organic forms, and by the duality of nature versus the machine. Ironically, Renger-Patzsch believed that nature and industry shared some purely visual concerns.

The influence of nature on Renger-Patzsch is recognizable in this study, *Flatirons for Shoe Manufacture.* At the Folkwang Publishing House Renger-Patzsch photographed some exotic plant specimens of the succulent family; some of his best photographs are of plants with branches bearing spines or scales structured in systematically repeating patterns. The photographer of industrial and commercial products was responsible for arranging his subjects before the photograph could be made. In grouping the flatirons like this, Renger-Patzsch seems to deliberately recall the patterns he found in nature. The viewer, however, can also imagine the flatirons as trees in a forest, or as soldiers standing at attention for a military review. WN

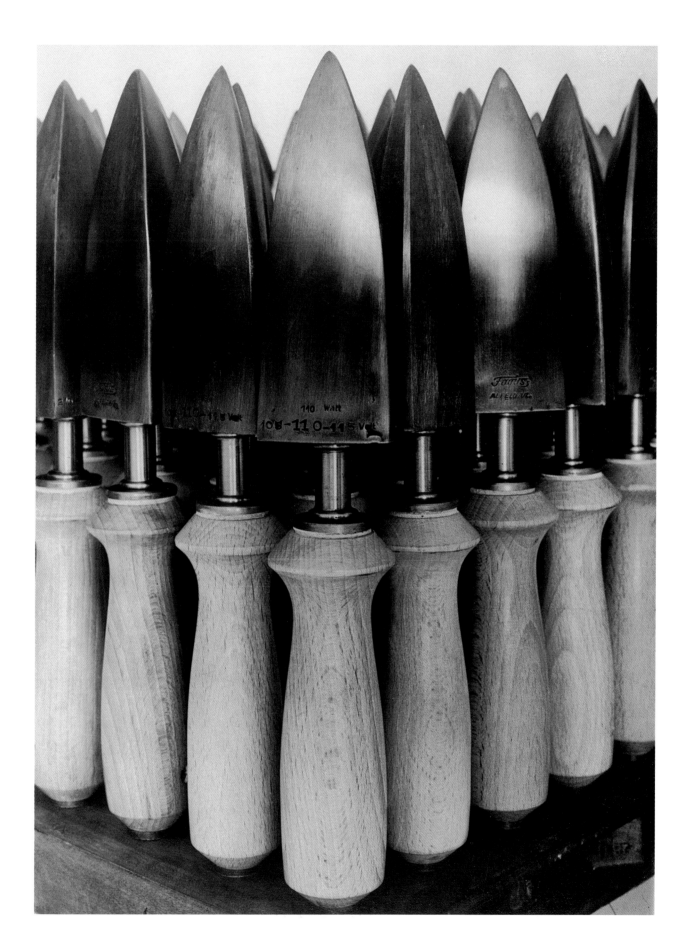

37 LÁSZLÓ MOHOLY-NAGY
American (born Hungary),
1895–1946
The Olly and Dolly Sisters,
circa 1925

Gelatin silver print
37.4 x 27.5 cm (14¾ x 10¹³⁄₁₆ in.)
84.XM.997.24

László Moholy-Nagy left his native Hungary for political reasons and arrived in Germany in 1920. His Berlin studio became a popular meeting place for artists from all over the world, and his own artistic philosophy reflects this diversity of influences. Moholy-Nagy worked in a wide variety of media, including painting, photography, and film, and he taught at the Bauhaus school of design in Weimar from 1923 to 1928. He later emigrated to the United States, where he founded the New Bauhaus school in Chicago (now known as the Institute of Design), based on the principles of its namesake in Germany (see no. 39).

Moholy-Nagy's exploration of the creative possibilities of photography, begun in 1922, reveals his interest in pushing the limits of the medium. His photomontages are one example of his inventive approach: images for these compositions were cut from popular magazines and pasted together in surprising combinations, then rephotographed to create a seamless effect. The title of this piece refers to the Dolly Sisters, a dance team popular in Europe and the United States from 1911 to 1927. The identical twins, Jenny and Rosie, performed at the Moulin Rouge and in the Ziegfeld Follies and were known both for their beauty and for their gambling prowess. The sisters spent their last years in Los Angeles and are interred at Forest Lawn Cemetery in Glendale.

Factual knowledge is of little assistance in interpreting this photograph, however. We recognize the shape of a costumed performer, yet the eye is immediately drawn to the void created by the black circles. They not only thwart our expectations of intelligible visual components in the picture, but they also create a kind of negative space, a spot that seems to transform into a hole as we look at it. Is the dolly sitting on top of the world, or is she about to fall into the emptiness? The dot over her face depersonalizes her and contributes to a mood of alienation that is reinforced by the blank space surrounding her. An unresolved tension results from the incongruity between the cheerful subject suggested by the title and the headless state of the dancer.

KW

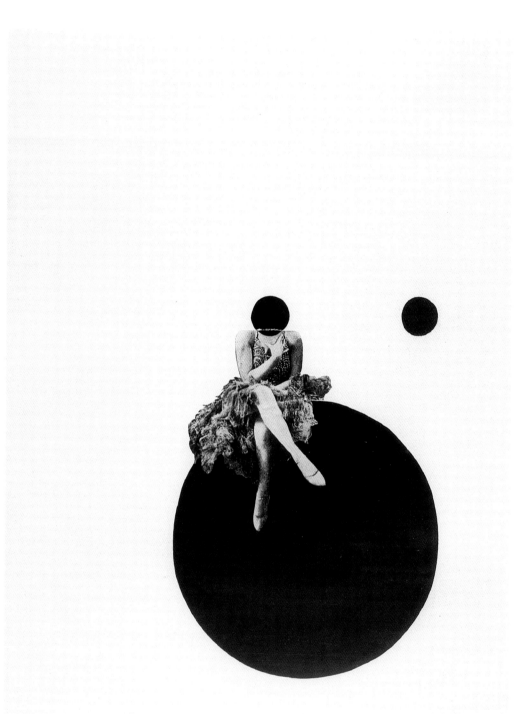

38 AUGUST SANDER
German, 1876–1964
Young Farmers, circa 1914

Gelatin silver print
23.5 x 17 cm (9 ¼ x 6 ¹¹⁄₁₆ in.)
84.XM.126.294

Between 1910 and 1912, August Sander decided to forsake his portrait studio—and his sophisticated clients—in the Cologne suburb of Lindenthal in favor of photographing farmers and other inhabitants of the surrounding countryside. He commuted by train and bicycle from Lindenthal to the Siegerland and Westerwald districts, where he had spent his childhood. Disembarking from the train, he would pack his equipment on the bicycle and prospect for clients along the country lanes. There he encountered subjects like the young farmers in this image, possibly his first masterpiece. Without the controlled environment of a studio, its predictable lighting, an established position where the camera was stationed, and another location where the subjects were posed, Sander had to be quite resourceful in using his camera to establish the figures in the landscape setting familiar to them.

Sander's talent was in seeing the familiar in unfamiliar ways. This roadside portrait attains a sense of mystery because of the powerful way that the photographer has harnessed accident and chance. The subjects are not posed but rather seem to have been caught off guard in their travels along the dirt path. The exposure was made with the lens aperture set at a large opening, causing the out-of-focus background and diffuse texture. The spontaneity and sense of a situation unfolding are quite different from the frontal poses typical of Sander's studio work up to this point. This may be one of the first pictures in which Sander was aware of his own art as cultural history built from portraiture. Calling the first collection of these photographs *Antlitz der Zeit* (Face of the Time), Sander later used the phrase "Man of the Twentieth Century" to describe the encompassing scope of this body of work.

The substance of Sander's method—a sensitivity to details of costume, an appreciation of the revealing gesture, pose, or facial expression, and a sharp eye for the symbolic attributes of a station in life (here the suits, hats, and canes)—allowed him to shift between social documentation and traditional portraiture. WN

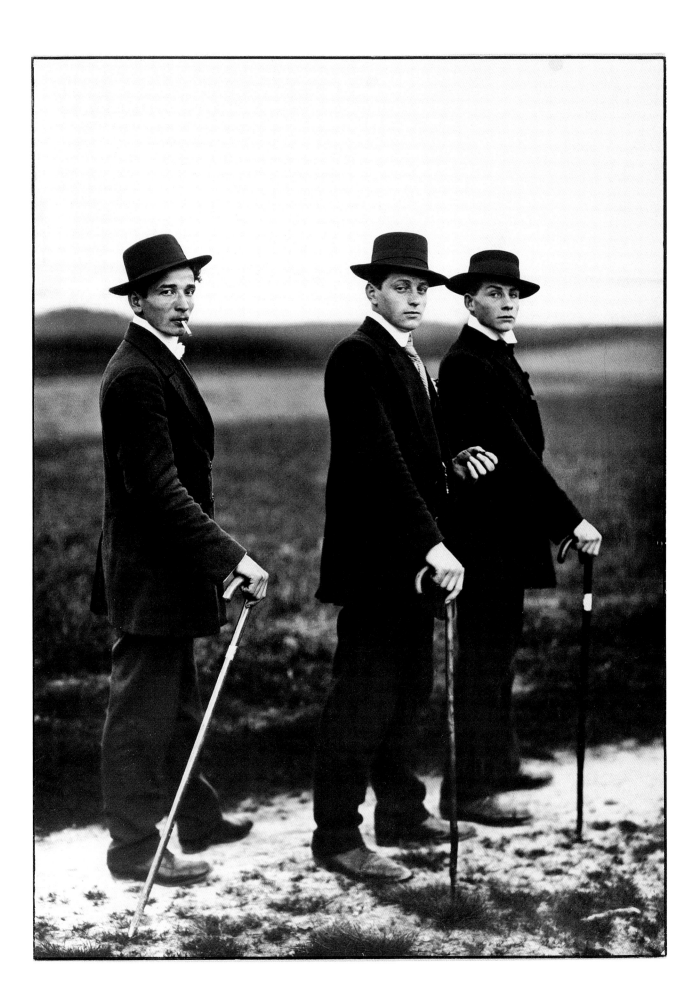

39 T. LUX FEININGER
American (born Germany),
1910
Bauhaus Band, circa 1928

Gelatin silver print
11.3 x 8.3 cm (4⁷⁄₁₆ x 3¼ in.)
85.XP.384.94

T. (Theodore) Lux Feininger was nine years old when his family moved to Weimar; his father, the painter Lyonel Feininger, had accepted a teaching position at the Bauhaus school of design. T. Lux (the Latin word for "light") began his studies there in 1926, with an emphasis on theater arts. He graduated in 1929, the year photography classes were introduced. Feininger was attracted to the medium as early as 1925, as evidenced by numerous pictures of him with a camera hanging around his neck. However, he was less interested in using photography as an artistic medium than in recording events of personal importance, such as theatrical and musical performances, parties, and the high jinks of his fellow students.

The Bauhaus sponsored many parties and balls that were the occasion for creative costumes, and the students formed a Dixieland band (in which Feininger played clarinet and sometimes banjo) to perform at these events. This lively picture of Bauhaus jazz band members was probably taken on the school's roof. In it Feininger deftly captures the spontaneous interplay of the participants, expressing the exuberance of the music and the joy of his young friends.

Although masterfully composed, the picture has a snapshot quality that suggests a moment snatched from time. Waldemar Adler vigorously strums a banjo worn by Ernst Egeler, while trombonist Josef Tokayer precariously perches on a ladder that appears to be wobbling in time to the music, sending his cap flying. This house of cards probably collapsed a moment after the camera captured it on film forever.　　　KW

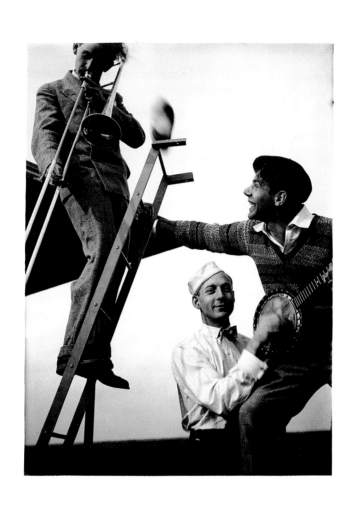

40 WALKER EVANS
American, 1903–1975
Citizen in Downtown Havana,
1933

Gelatin silver print
22.3 x 11.8 cm (8¾ x 4⅝ in.)
84.XM.956.484

Detail overleaf

Walker Evans is thought by many to be responsible, through his photographs, for our conception of the American Depression as well as for the way we imagine the American South. The son of an advertising man, Evans was born in St. Louis, grew up in Illinois and Ohio, and attended various Eastern prep schools. His distinctive photographic style—which has been called quintessentially American and often declared Documentary—was nurtured by New York in the late 1920s and honed by his experiences abroad. In the spring of 1933 Evans was commissioned to travel to the Caribbean to provide illustrations for Carleton Beals's book *The Crime of Cuba.* Havana became for Evans what Paris had been for the photographer Eugène Atget earlier in the century (see no. 35), a city that he could take on as a powerful subject, describing it in detail while recasting it in his own vision.

Evans's Havana citizen might be considered an updating of Charles Baudelaire's nineteenth-century dandy, someone whose "solitary profession is elegance" and whose natural element is the crowd. It is not only the unusual height of Evans's idiosyncratic flaneur but also his expressive face, appearing at the same time wise and evil, ancient and contemporary, that make this a startling portrait. The photographer situates this mysterious gentleman on a busy street corner and surrounds him with the ordinary, but still provocative, contrasts of glamorous movie-magazine faces, American ads, and the innocent countenance of a shoe-shine boy.

This figure might also be seen to represent what Beals described as the overwhelmingly masculine quality of Havana's streets. On another level, Evans's reference to this heroic individual as a citizen of Havana could well be somewhat ironic, applying as it did to a member of a disenfranchised population that, according to Beals, felt like exiles in their own land. The motif of the anonymous man-on-the-street is one to which Evans would return throughout his career: while working for the United States Resettlement Administration and *Fortune* magazine in Mississippi, Florida, Bridgeport, Detroit, Chicago, and while walking the streets of his own "village," Manhattan. JK

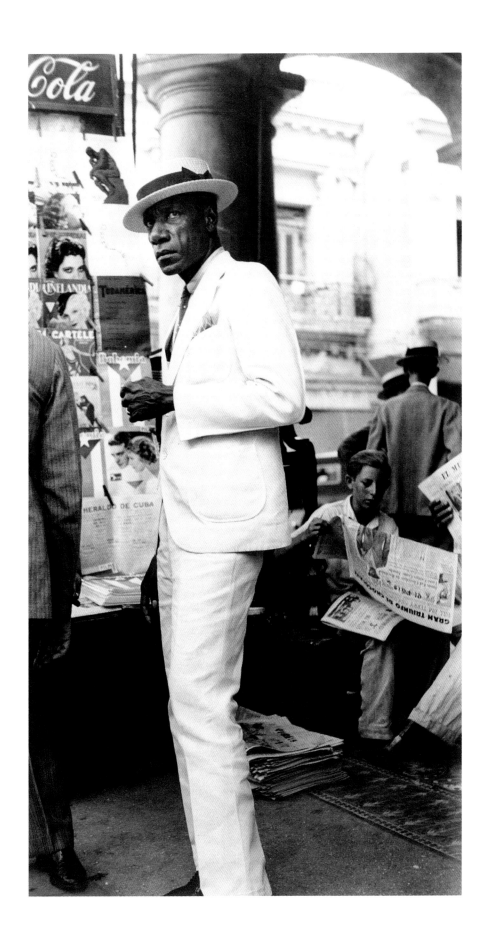

41 MANUEL ALVAREZ
BRAVO
Mexican, born 1902
The Daughter of the Dancers,
1933
Gelatin silver print
23.3 x 16.9 cm (9 3/16 x 6 5/8 in.)
92.XM.23.23

In a career that spans many decades and reflects numerous changes in artistic fashion, Manuel Alvarez Bravo continues to produce thought-provoking photographs. Although his work went unrecognized for years in mainstream art circles, he is now considered by many to be one of Mexico's greatest artists.

Alvarez Bravo began his career when Modernism first flowered in Mexico and the influence of the Mexican Revolution was still palpable. Experimenting in different artistic media before settling on photography, he interacted with most of the great Mexican artists during the 1920s and 1930s. Alvarez Bravo also developed formative ties with such expatriate photographers as Paul Strand, Edward Weston, Tina Modotti, and Henri Cartier-Bresson. These various relationships brought a strong Modernist aesthetic to his photographs, which he combined with a sense of the Mexican spirit. Alvarez Bravo's work was admired by the Surrealists, especially André Breton, who commissioned a photograph for the brochure cover of the 1939 Surrealist Exhibition from him. Besides his still photography, Alvarez Bravo worked as a cameraman at the Sindicato de Trabajadores de la Producción Cinematográfica de México with such filmmakers as Sergei Eisenstein, Luis Buñuel, and John Ford.

Much of Alvarez Bravo's work is characterized by contemplative subject matter and the use of poetic titles. Nothing in the girl's appearance implies that she is the daughter of the dancers, or a dancer herself, except possibly the positioning of her arms and the way she stands on her own foot to peer inside the round window. This photograph shows a near-perfect balance of light, line, and form. The circles in the girl's hat echo the circles of the window. Her tilted arms reflect the angle of the painted tiles. The geometry of the composition illustrates the patience and thought that went into Alvarez Bravo's photography of anonymous people engaged in ordinary activities. JM

42 DORIS ULMANN
American, 1882–1934
*Sister Mary Paul Lewis,
New Orleans*, 1931

Platinum print
21.3 x 16.3 cm (8⅜ x 6⅜ in.)
87.XM.89.80

A native New Yorker, Doris Ulmann studied psychology but ultimately took up photography as her life's work. The humanist philosophy of the Ethical Culture School and the socialist concerns of her mentor, the Pictorialist Clarence White, probably contributed to her passion for portraiture—whether photographing members of the Manhattan literati, the Shakers of the original Mount Lebanon colony, or the craftsmen of the Kentucky mountains. Her associates in this mission to collect portraits and preserve American folklife were the balladeer John Jacob Niles, the Russell Sage Foundation researcher Allen Eaton, and the South Carolina novelist Julia Peterkin. Ulmann's collaboration with Peterkin produced *Roll, Jordan, Roll* (1933), an overview in expository prose, fiction, and photographs of dwindling rural black culture. Often employing folktales and local dialect, Peterkin's vivid text complements the sensitive portraits Ulmann made with her bulky view camera.

Ulmann and Peterkin probably met in 1929 during the latter's New York celebration of the Pulitzer Prize she had just received for her latest novel, *Scarlet Sister Mary*. Soon after this, Ulmann traveled with Peterkin throughout Louisiana, Alabama, and South Carolina and visited her plantation, Lang Syne. At Peterkin's urging, Ulmann made several trips to New Orleans between 1929 and 1931. There she became intrigued with the Creole and Cajun residents as well as with the Sisters of the Holy Family convent, a French Quarter community founded in 1842 by free women of color. She photographed the sisters individually, in groups, and with their students at the convent's school for boys.

Sister Paul, whose father was an educated sharecropper in Natchez, Mississippi, entered the house in 1895 and served the order until her death at the age of 101 in 1977. Reflecting Ulmann's interest in the life of cloistered or isolated communities, this portrait presents an individual of unusual dignity and regal bearing. Unlike much of Pictorialism, it is eloquent without being overtly narrative, and the soft edges of platinum printing do not suppress the bold appeal of this honest face. JK

43 ANDRÉ KERTÉSZ
American (born Hungary),
1894–1985
Arm and Ventilator, New York,
1937
Gelatin silver print
13.6 x 11.3 cm (5⅜ x 4⁷⁄₁₆ in.)
85.XM.259.15

Although he resided and worked in Paris for eleven years and in New York for over forty, André Kertész spoke French and English imperfectly and was fluent only in his native language, Hungarian. His photographs in large measure compensated for his lack of verbal facility; they evolved as a personal language of expression. For Kertész, photography provided comfort and a way of arriving at an emotional and psychological understanding of the world. The freshness and sincerity of his vision led the Surrealist poet Paul Dermée to declare that "his child's eyes see each thing for the first time."

After discovering the 35 mm Leica camera in Paris in 1928, Kertész preferred to work with highly portable equipment, to allow extra speed and responsiveness in picture-taking. He once recalled, "the moment always dictates in my work.… Everybody can look, but they don't necessarily see.… I see a situation and I know that it is right." Kertész's preeminent ability as a photographer lay in seizing and revealing beauty in moments that might appear trivial or commonplace to anyone else.

His visual isolation of the disembodied arm of a repairman working on the ventilation fan of a drugstore located at Fifth Avenue and Eighth Street in Greenwich Village, New York, reveals a wry wit and a fascination for the elusive, circumstantial magic that is so much a part of human life. From his vantage point at street level, Kertész directs the camera upward, flattening the space and capturing the light and shade that are simultaneously cast on the blades of the ventilator. The repairman's arm is ominously wedged between two steel blades, and only closer inspection reveals the faintest traces of his figure in the dark interior of the drugstore. By removing from the frame any information that would explain the circumstances behind this curious union of man and machine, Kertész creates an enigmatic, thought-provoking image. JC

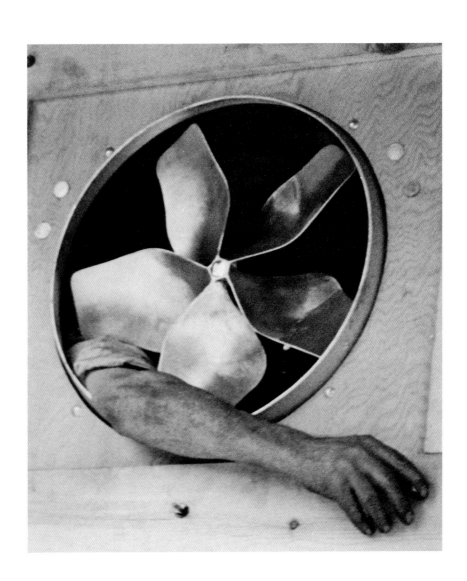

44 BARBARA MORGAN
American, 1900–1992
Erick Hawkins, "American Document," circa 1938

Gelatin silver print
26.4 x 27.3 cm (10⅜ x 10¾ in.)
96.XM.63.4
Gift of Richard E. Riebel in
memory of Audrey R. Riebel

In the 1930s, after moving to New York from Southern California and giving birth to two sons, Barbara Morgan applied her interests in Asian art and philosophy, Native American ritual, and Dada collage to her own photographic experiments with photomontage, light abstractions, and dance photography. In fact, her decision to transfer her creative energies from the canvas to the darkroom coincided with her first exposure to modern dance and the avant-garde artistry of Martha Graham, who had been teaching and performing in New York since 1925.

Although Graham at first focused on solo or uncomplicated staging, by the late 1930s her dance troupe included two men, Merce Cunningham and Erick Hawkins, and her choreography extended to "dance documentary," as she described the ambitious 1938 piece called "American Document." Hawkins, a companion of Graham and, briefly, her husband, danced in "Document" as her first male partner in a decade. The extreme simplicity of this composition does not diminish its expressiveness. Hawkins's powerful stride suggests a modern man, while his strongly lit masculine anatomy recalls the classical ideals of the antique. Capturing precisely the right gesture, Morgan's camera creates a heroic sculpture in two dimensions.

Morgan did not simply attend the theater and photograph the dance in progress. She called her way of working "absorbing the spirit of the dance," and for this the staged rehearsals and performances were only preliminary. The actual work was usually accomplished in her own studio, where she collaborated with the dancers in re-creating movements she had selected as "significant gestures." In the late 1930s, she preferred shooting the dance with her 4 x 5-inch Speed Graphic camera against a versatile white background, lit specifically with floods and spotlights for each "climactic" movement. A fine-grain developer allowed her to obtain negatives that could be successfully enlarged to as much as 16 x 20 inches, providing the increased size she felt essential to evoke the expression of the dance. JK

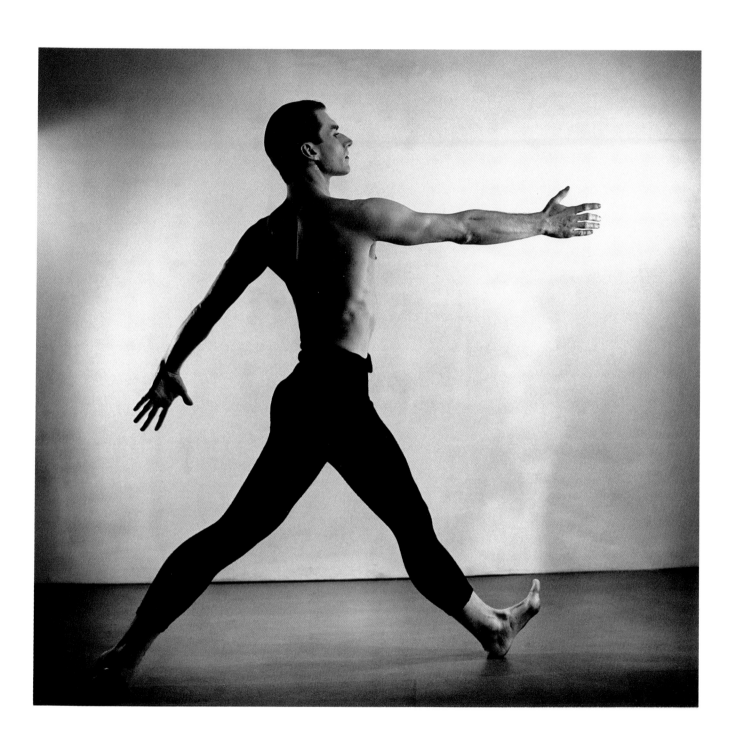

Known primarily as a Precisionist painter, Charles Sheeler was also a highly regarded photographer of architecture and industry. With a strong interest in the roots of American architecture and design, he made some of his first photographs in Bucks County, Pennsylvania, using the barns and farmhouses of the region as subject matter. The characteristics of his best paintings—objectivity, sharp definition, and pictorial flatness—carry over into much of his photography. Encouraged by Alfred Stieglitz's interest in his photographs, Sheeler moved to New York in 1919, where he photographed the city from unusual perspectives emphasizing abstract geometrical forms.

In 1939, *Fortune* magazine commissioned Sheeler to create a portfolio of paintings entitled *Power* to celebrate the industrial machines that were at the heart of America's wealth and infrastructure. One subject was the steam locomotive. Not having the time to sit and study the drive wheel of this New York Central locomotive, he made a number of photographs to serve as models for a painting. Meticulous research led Sheeler to this specific type of engine, considered "the most handsome of all streamlined locomotives." His fragmented vision of the train abstracts the bulk and power of the engine into complex layers of circles, horizontal lines, and subtle diagonals, augmented by highlights and shadows. The viewer perceives the entire locomotive behind the hard-edged details of the drive wheel, the smaller "bogie" wheels, and the condenser. This last unit, the condenser, releases a small puff of steam that both identifies the component energy source and offers a visual counterpoint to the crisp outline of the machine. In his painting *Rolling Power* (collection of the Smith College Museum of Art, Northampton, Massachusetts), which was based on this photograph, Sheeler captures the mechanical essence of the wheels with his concise brushstrokes and monochromatic palette. JM

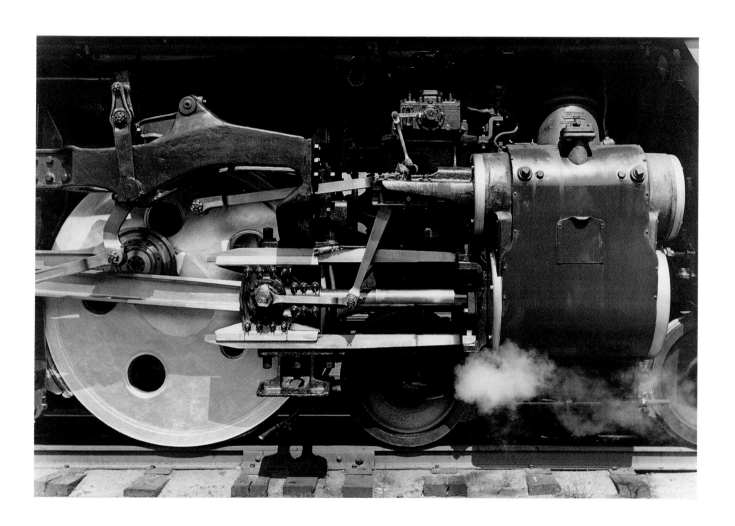

46 WEEGEE
(Arthur Fellig)
American (born Poland),
1899–1968
Their First Murder, before 1945

Gelatin silver print
25.7 x 27.9 cm (10⅛ x 11 in.)
86.XM.4.6

Detail overleaf

A Polish immigrant, Weegee—who took his name from the Ouija board (pronounced "wee-gee" in his adopted country)—is most famous for his distinctive depictions of urban mayhem in the United States' most populous and culturally diverse city, New York. Weegee had an uncanny knack for turning up at a murder, fire, or other disaster before the authorities did by listening to a police radio; hence his pseudonym. He was a self-taught practitioner who scratched out a living, and later in life a certain amount of fame, as a freelance photographer specializing in crime-scene images for New York's daily tabloids. Many of his images focus on the spectators and gawkers who gathered around for the spectacle of an event immediately after it occurred. While the body of a murder victim offers somewhat limited photographic possibilities, the surrounding crowds present a startling range of emotions and reactions. Weegee also took many photographs of different classes of New Yorkers, from the wealthy elite at an opera premiere to the down-and-out drunks in the Bowery.

The title of this photograph belies the carnival-like atmosphere of the image while encapsulating a sense of the cynicism and disorder of modern New York. The viewer is confronted by a tangled mass of humanity, all straining to witness some unseen calamity. The beauty of this photograph lies in its panoply of human emotions: glee, curiosity, anger, fear. Almost lost in the crush of heads is the grief welling up on the face of a female relative of the murder victim. Weegee's flashbulb bathes the onlookers in a harsh, unflattering light while plunging the background into darkness. The need to rush to editors photographs that would then be printed on half-tone presses precluded the need for subtle printing. Weegee's photography anticipates such later masters as Robert Frank, Garry Winogrand, and Diane Arbus. JM

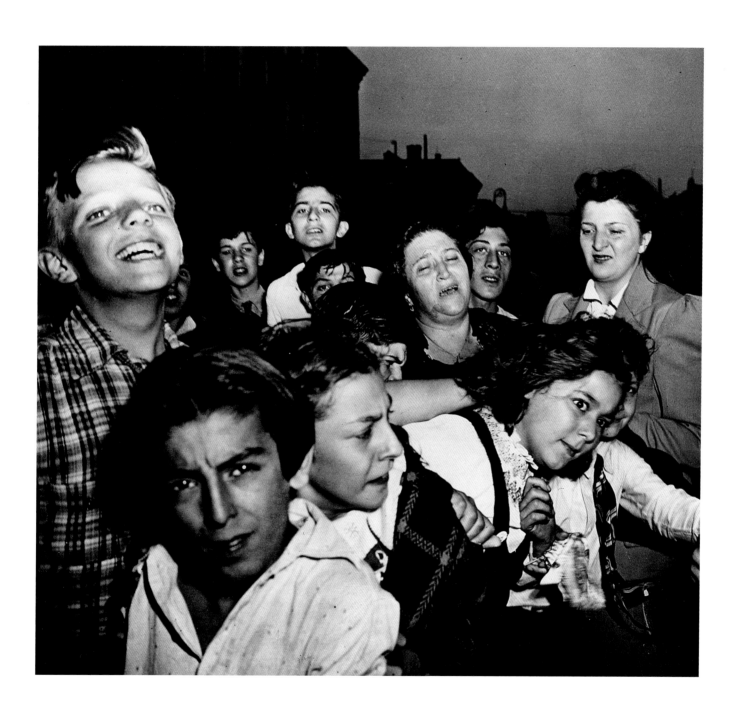

47 LISETTE MODEL
American (born Austria),
1901–1983
Reno, 1949

Gelatin silver print
34 x 27 cm (13 7/16 x 10 5/8 in.)
84.XM.153.63

Born in Vienna, Elise (Lisette) Stern moved to Paris as a young woman and studied both music and painting before taking up photography as a profession. Three women tutored and encouraged her in this new vocation: her sister Olga, Rogi André (the first wife of André Kertész), and the master of photomontage, Florence Henri. In 1938 Lisette and her husband, the painter Evsa Model, emigrated to New York, where she found increasing success with photojournalism, publishing in *PM Weekly, Harper's Bazaar, Life, Look, Vogue,* and the *Ladies Home Journal.* She also discovered a new public through the Museum of Modern Art's photography department, which opened in 1940 and promptly began exhibiting and collecting her work.

During the 1940s, Model was busy not only with her own shows and the documentation of New York café life, but some assignments also took her to the West. For the November 1949 installment of the *Ladies Home Journal* series "How America Lives," the magazine sent Model to Reno to report on the "typical" Winne family, operators of the Lazy A Bar Ranch. Model did create portraits of the family, but her camera and the final article reflected equal interest in a portrayal of the ranch guests —mostly women waiting out the six-week residency requirement for a divorce— and the ubiquitous gamblers of Reno.

None of the pictures Model made at a local rodeo, including this one, appeared among the images of dude-ranch leisure and casino commotion that finally illustrated "How Reno Lives." However, this portrait contains some fascinating dualities: the woman's provocative gaze is both glamorous and reticent, cosmopolitan and provincial, feminine and masculine. It is hard to say whether the subject is a bold, recent divorcée enjoying the spectacle of bronco riding or a nervous wife waiting for a decree to end a broken relationship. Perhaps the editors thought an intense glare that might frighten, rather than entertain, their readers was concealed behind those rhinestone glasses. JK

48 JOSEF SUDEK
Czech, 1896–1976
Last Roses, 1959

Gelatin silver print
29.7 x 23.5 cm (11¹¹⁄₁₆ x 9¼ in.)
84.XM.149.13

Detail overleaf

The implicit sadness of this photograph is echoed by its title, which makes it clear that this limpid composition does not depict a rainy day in summer. That season has drawn to a close and, although the trees have not yet lost their leaves, there will be no more blooms until after the long Czech winter. The elegiac mood of this image is characteristic of Sudek's work after he had turned from studies of Baroque architecture in Prague, later panoramic views of the city, and landscapes, to contemplative still lifes made in his house and garden and in those of his friends. Over time, he made a memorable series of still lifes staged either on a windowsill with panes of glass behind that were often streaked with rain, or on a round table in the center of his dwelling.

The stringent order imposed by the camera contrasts with the chaos of clutter just outside the camera's range. Sudek's rooms were filled nearly beyond capacity with a lifetime's accumulation of found objects, gifts, books, newspapers, family heirlooms, photographic materials, negatives, and prints. His gift for selecting a few objects from a plethora is evident. Here, a water glass with three roses, a cowrie shell, three thumbtacks, a camera lens cap, a stack of books, and a vase with the two halves of a broken eggshell across its mouth suffice. The delicacy of the flower petals is nearly palpable, emphasized by the contrast with the raindrops running down the window pane.

Although the poetic qualities of Sudek's work won him wide acceptance in Czech artistic circles, a more exact analogy might be to his passion for music, which led him to stage weekly musicales. This moody work, then, can perhaps be thought of as a twilight étude or as a requiem for a season. GB

49 FREDERICK SOMMER
American, born 1905
*Virgin and Child with
Saint Anne and the Infant
Saint John,* 1966

Gelatin silver print
24 x 17.7 cm (9⁷⁄₁₆ x 6¹⁵⁄₁₆ in.)
94.XM.37.39

In a career spanning more than six decades, Frederick Sommer has produced a relatively small, but exceptionally fine, body of photographs. An artist of multifaceted talent—which he has expressed in drawings, collages, paintings, and landscape and architectural designs—Sommer was inspired to make photographs after meeting Edward Weston in Los Angeles in 1936 (see no. 32). While he has always endeavored to match the supreme printmaking craftsmanship of Weston, Stieglitz, and Strand, Sommer's philosophical view of the medium is much different. He has embraced photography not to describe the appearance of the world, but to ask questions of it and explore the nature of things.

Imagination and transformation are central to Sommer's art. He has created remarkable photographs of still-life arrangements made from objects he has collected over many years. After a lengthy study of his materials, Sommer coaxes the elements of his picture into precise position. Describing this process, Sommer has stated: "If I could find them in nature I would photograph them. I make them because through photography I have a knowledge of things that can't be found."

To create this composition, Sommer combined a nineteenth-century children's book illustration with a peculiarly formed lump of hardened molten metal that he found in the burned-out remains of a wrecked automobile. Working with a large-format camera, Sommer transformed the scale and impact of the individual elements in the ground glass. The contours of the molten metal fragment approximate the grouping of figures in Leonardo da Vinci's drawing of the same subject in the National Gallery, London. The formal coherence of Sommer's placement is complemented by the measured distribution of shadows and highlights across the fragment, which serve as a perfect counterpoint to the homogenous tonal range of the book illustration. The marriage of such disparate pictorial elements into an integrated whole is a measure of Sommer's respect for the process of assembly and arrangement, through which the recognition of new meanings occurs. JC

50 EDMUND TESKE
American, 1911–1996
Cactus, Taliesin West,
Scottsdale, Arizona, 1943

Gelatin silver duotone solarized print
of the 1960s
33.7 x 24.8 cm (13¼ x 9¾ in.)
94.XM.29.2

In a diverse body of work produced over a sixty-year period, Edmund Teske consistently embraced photography as a means of expressing his intensely personal and highly imaginative response to the world within and around him. Teske's photographs are steeped in a self-crafted symbolism whose roots lie in the poetry of Walt Whitman and the Vedanta philosophy of Hinduism. A darkroom alchemist, Teske created images that display a heightened technical and emotional sensitivity and are charged with a mystical, poetic mood.

A native of Chicago, Teske took up photography as a schoolboy and developed his skills in a darkroom studio that he constructed in the basement of the family home. Working alone much of the time, Teske relied heavily on Ansel Adams's early writings to learn the fundamentals of light, optics, and darkroom technique. In 1934, he took a position as an assistant in a commercial studio, where he honed the technical expertise that was to form the basis of a lifetime's intuitive exploration in the medium. By 1936, Teske had been invited to take up a two-year fellowship with architect Frank Lloyd Wright at Taliesin East in Spring Green, Wisconsin. In what was the first photography carried out at Taliesin, Teske photographed the architecture and grounds and absorbed the teachings of the charismatic architect.

In 1943, Teske moved from Chicago to Los Angeles, where he resided until his death in 1996. On his journey west, he stopped at Wright's winter headquarters, Taliesin West, in Scottsdale, Arizona, and made this striking study of a cane cholla cactus in the desert surrounding the complex. Twenty years later, he returned to the negative and dramatically reprinted the image, employing the unique, haphazard qualities of his self-styled technique of duotone solarization. In this process, the partially developed print is exposed to light and then re-immersed in developing chemicals, which produces in the finished print a striking burnished surface of rich cobalt blues and deep russet tones. The totemic forms of the cactus seem to float to the surface, creating an image that is simultaneously descriptive and powerfully abstract, a union of opposites that Teske described as "a very beautiful circular interplay between two levels of being." JC

INDEX OF ARTISTS
Numerals refer to page numbers